THREE TREATISES ON THE DIVINE IMAGES

ST VLADIMIR'S SEMINARY PRESS
Popular Patristics Series

Editor
JOHN BEHR

ST JOHN OF DAMASCUS

Three Treatises
on the Divine Images

Translation and
Introduction by

ANDREW LOUTH

First Edition

ST VLADIMIR'S SEMINARY PRESS
CRESTWOOD, NEW YORK 10707

LIBRARY OF CONGRESS CATALOGING-IN-PUBLICATION DATA

John, of Damascus, Saint.
 [On the divine images. English]
 Three treatises on the divine images / St. John of Damascus ; translation
and introduction by Andrew Louth.—1st ed.
 p. cm.— (St. Vladimir's Seminary Press "popular patristics" series)
 Includes bibliographical references (p.).
 ISBN-13: 978-0-88141-245-1
 ISBN-10: 0-088141-245-7

 1. Icons—Cult. 2. Iconoclasm. I. Louth, Andrew. II. Title. III. Series

BR65.J63O513 2003
246'.53—dc21

 2002031920

COPYRIGHT © 2003
ST VLADIMIR'S SEMINARY PRESS
575 Scarsdale Road, Crestwood, NY 10707
www.svspress.com • 1-800-204-2665

ISBN 978-0-88141-245-1

PRINTED IN THE UNITED STATES OF AMERICA

Table of Contents

Introduction

In AD 726 the Byzantine Emperor Leo III ordered the destruction of icons, or religious images, throughout the Byzantine Empire. The reasons for this policy are not clear, for lack of firm evidence, though it seems that justification was sought in the allegation that the veneration of icons amounted to idolatry, in contravention of the second commandment. In 730 the Emperor took his policy of iconoclasm still further, issuing a formal edict and, when opposed by the Patriarch of Constantinople, Germanus I, requiring him to resign. Thus was inaugurated a period in which icons were subject to an imperial ban throughout the Byzantine Empire that was to last, with a brief remission from 786 to 815, until 843, when iconoclasm was finally rejected as imperial policy and the restoration of the veneration of icons hailed as the "Triumph of Orthodoxy" in a ceremony that became annual, and still continues to be celebrated in the Orthodox Church on the First Sunday of Lent.

The period of iconoclasm coincided with a time of dramatic change for the Byzantine Empire. These changes were principally caused by the events of the seventh century, during which the Byzantine Empire suffered the loss of its provinces in the east and south of the Empire—from Syria, down through Palestine to Egypt, and eventually along the Mediterranean coast of Africa—to the emergent Islam of the Arabs, and loss of control of the Balkan provinces south of the Danube, which were largely settled by Slavs from the Central European Plain in the early years of that century. The Byzantine Empire—or the Roman Empire, as it thought of itself—shrank to little more than Constantinople and Asia Minor, which suffered

yearly invasion from the Arabs, together with Thessaloniki and
Thrace, which were under constant threat from the Slavs and the
more warlike Avars, and later, Bulgars; contact between the capital
and the provinces in southern Italy was rendered fragile. A proud,
worldwide empire became an embattled Eastern Mediterranean
state hemmed in between the vast might of an Islamic Empire to the
east and the growing power of the Carolingian Empire to the west,
though the latter was only in the course of development in the eighth
century. Iconoclasm was probably, from one point of view, part of
the Byzantine Empire's response to this catastrophic situation, along
with administrative changes, as a result of which the Byzantine
Empire lost its provincial structure and was organized into regions
called "themes," administered by a military commander and a stand-
ing army. Both the administrative changes and iconoclasm facili-
tated the centralization of power on the military leadership of the
Emperor.

Iconoclasm meant the destruction of icons and the forbidding
of their veneration. By "icons" is to be understood in this context any
form of religious art, whether mosaics, frescos, decoration of sacred
vessels, garments and books, even statues, as well as paintings on
board, which is what the word tends to mean nowadays (the word
"icon" is simply a transliteration of the Greek word for an image,
eikon). By the beginning of the eighth century, icons were a promi-
nent feature of Byzantine society, both in public and in private.
Scholars differ as to whether the place of visual imagery in Chris-
tianity was an alien incursion in the course of the fourth century, in
the wake of Constantine's conversion and the gradual "Christian-
ization" of the Empire, or something that had much deeper roots.
Whatever its origins, the role of the icon increased enormously from
the sixth century onwards. The veneration of saints through their
images, or icons, became an important part of Christian devotion,
both in church and in private houses, and such sacred imagery came
to be used to reinforce the Emperor's claims to supreme earthly
authority that had long been expressed through visual imagery,

including the statues of the Emperor found throughout the Empire. The successful defense of the cities of the Empire against the constant threat from invading forces—Slavs and Avars, Arabs, and before them the Persians—was widely attributed to the saints: for example, the Mother of God in the case of Constantinople, and St Demetrius in the case of Thessaloniki. When Leo III banned icons in 726, he was attacking a popular and well-established practice.

John of Damascus

Among the defenders of icons and their veneration at the outbreak of iconoclasm, the most distinguished was Saint John Damascene. A native of Damascus, he was by then a monk in the region of Jerusalem (by tradition, though a late one, the Monastery of Mar Saba, known as the Great Lavra, in the Judæan Desert). Almost certainly he never in his life set foot on territory ruled by the Byzantine Emperor. On the contrary, he had spent the first part of his life in the service of the Muslim Caliph at Damascus (the capital of the Umayyad Empire, which lasted from 661–750), following the example of his father and grandfather, who had been responsible for the fiscal administration run from Damascus for about a century, and had served the Byzantine Emperors and the Persian Shah before the Arab conquest in 635. Probably about 706, when the Caliph al-Walid made his administration more thoroughly Muslim, John left Damascus and became a monk. We are not sure how old John was by this time—anywhere between 30 and 55—but he spent the rest of his life as monk near Jerusalem. He died probably about 750, since, at the Byzantine synod held in Hiereia in Chalcedon in 754 to declare support for iconoclasm, he was condemned, under his Arab name Mansur (rather than his monastic name, John), as someone already dead. It was certainly because John was beyond the reach of the Byzantine Emperor that he was able to criticize the Emperor and his policy of iconoclasm so freely.

The Treatises against the Iconoclasts

John wrote three treatises against "those who attack the holy images," or it might be more accurate to say that he wrote against the iconoclasts three times, for the three treatises are not at all independent: the second treatise makes use of large parts of the first, and is explicitly a simplified version of it; the third treatise follows the second quite closely to begin with, and then develops a systematic theological section, based largely on the first treatise. From that the order of the treatises is clear. The second treatise was evidently written when the news of the deposition of Patriarch Germanus reached Jerusalem, therefore shortly after 730; the first knows nothing of this, and so must be between 726 and 730. The third treatise is more of a cool treatise than an impassioned tract and, given that the florilegium attached to it is very much longer than the earlier florilegia, it is likely that it was composed somewhat later, say in the early 740s (but not late enough for John to have learnt about the way Leo III's son, Constantine V, was seeking to justify iconoclasm in the late 740s). Despite their overlap, they are very different treatises.

The first is an immediate response to the news of iconoclasm. John declares his reluctance to get involved in controversy, but quickly gets into his stride with an impassioned defense of icons and their veneration. Much of the argument turns on the meaning of the key terms: icon and veneration. In the case of icon, or image, John sets out the centrality of this term in Christian theology, illustrating the different roles this key term plays, from characterizing the relationships within the Trinity—the Son as image of the Father, for instance—to describing the way in which God relates to the created order through his divine intentions, images of which are brought into effect through providence, the way in which visual images give us some inkling of invisible realities, the way in which the Old Testament contains images that foreshadow the New, and the way in which images, both in writing and in painting, remind us of past events and people. Attacking images, John seems to be saying, is not

just to attack the actual icons, but more seriously to threaten something central to the whole fabric of Christian theology. The other key term, veneration, is then subject to the same drawing of distinctions. The Greek word I have translated "veneration" (following what seems to be the established custom among English-speaking Orthodox) is *proskynesis*, which properly speaking refers to an *action*, the action of bowing down to the ground. In drawing his distinctions, John points out that we make such an act of veneration for several reasons: in relation to God, we bow down to express our exclusive worship (as I have translated the Greek *latreia*) of God, but we also bow down, and venerate, other things, people and sacred things, out of respect (Greek: *timē*). In fact, these two meanings of veneration are related: we venerate things, places and people associated with God, as a way of showing respect to what belongs to God; but God alone is the object of our worship, which we also express through veneration, or bowing down. These two arguments make clear two fundamental points: first, the importance of the image as a way of discerning anything at all about God and his purposes, and secondly the difference between the veneration of icons, which is a matter of expressing honor, *timē*, and idolatry, which is offering *latreia* to something other than God, something forbidden by the second commandment (apparently, as already noticed, the justification given for iconoclasm). In this treatise John also appeals to the worship of the Old Testament, in which acts of veneration were offered to all sorts of things, such as the ark of the covenant and Aaron's rod, as well as the images of the cherubim, made of bronze, and furthermore grounds his argument on the fact that matter is created, and so not to be despised, as iconoclasm would seem to imply, but even more on the fact that the Son of God himself assumed a material form in the Incarnation. John dwells on the value and beauty of matter, and suggests that the iconoclast despising of matter betrays an inclination towards Manichæism. But for John the strongest argument of all, introduced early on in the treatise, is based on the Incarnation: even if the veneration of images was forbidden in the Old

Testament (which, he maintains, it is not), because God has no visible form, this situation has changed as a result of the Incarnation, in which the invisible and incomprehensible God has taken on himself a material form. The first treatise continues with an appeal to unwritten tradition, in which he invokes a famous passage from St Basil's *On the Holy Spirit*, rejects the appeal made by the iconoclasts to passages allegedly from St Epiphanius, and then continues by citing a collection of patristic texts (a florilegium), on which he provides a running commentary. He concludes by taking the emperor to task in no uncertain terms, accusing him of piracy in usurping the role of the bishops in seeking to define Christian belief.

What is amazing about this first treatise, apparently written in the heat of the moment, is the confidence of the argument and its theological depth. Part of the reason for this emerges in the florilegium, the collection of patristic quotations, with which it concludes, for there we find, not only John's sure-footed appeal to authority, but also some hints of earlier controversy in which Christians had already been forced to defend the veneration of icons (and the Cross and the relics of the saints). Most striking, in this respect, are the long extracts from Leontius, bishop of Neapolis in Cyprus. John's quotations are from a treatise against the Jews, that is otherwise lost (other works of Leontius survive, mainly works of hagiography). Clearly Leontius, in the middle of the seventh century (he was one of the signatories of the Synod of Lateran in 649, which condemned the Christological heresies of monenergism and monothelitism), had found himself required to defend Christian practice against Jews, who accused Christians of idolatry because of their veneration of the Cross and icons and relics of the saints. This presumably reflects a situation in which, after the rise of Islam, many Christians found themselves deprived of imperial support and having to defend themselves against religious groups—heretics, Jews, maybe even Samaritans and Manichees—they could have safely ignored in the sixth century. Leontius is clear that the actual practice of worship under the Old Covenant was much richer than that of his

Jewish contemporaries, and is very clear that honoring sacred people and places for God's sake is very different from idolatry. This explains part of John's immediate ability to respond to Byzantine iconoclasm. More broadly, however, the clear sense of what Orthodox Christianity stood for is something that John inherited from the Palestinian monks whose numbers he had joined. The Palestinian monks, the guardians of the Holy Sites, had a long reputation as defenders of Orthodoxy: the Christological Orthodoxy of the ecumenical synods, especially Chalcedon. During the century after the Arab Conquest of the Near East, for the reasons mentioned above, they developed a facility for defending and defining Orthodoxy against all comers. This was the heritage into which John had entered, and his *On the Orthodox Faith* is a kind of treasury of this accumulated wisdom. Another, on an apparently narrower topic, is these treatises on the divine images against the iconoclasts.

The other two treatises, or his two reworkings of the treatise, are rather different from the first. The second is explicitly a simplified version of the first, which some found rather difficult, but it is also a response to further developments in Byzantine iconoclasm, principally the Emperor's deposition of the Patriarch, and also news about iconoclasm in Cyprus. It is, in my view, a drastic simplification, and embraces a form of polemic that is potentially ugly. John simplifies the argument from the Incarnation, so that it takes this form: the Jews were forbidden to make images, because they were disposed to idolatry, but Christians, who believe in the Incarnation, are free from that propensity and so may and must make icons. The anti-Jewish supersessionism (i.e., the Jews belong to the past, and we Christians have supplanted them) is potentially quite ugly, though its immediate polemical purpose is to smear the iconoclasts, who feared idolatry on the part of Christians, with being Jewish, or having Judaïzing tendencies. Most of the rest of the treatise is a sharp rebuke to the Emperor for involving himself in religious matters that are none of his business. In this section, John, who, as we have noted, never set foot on Byzantine soil, attacks the Emperor as *his*, and

adopts the tone of a Byzantine churchman. He repeats his accusation of piracy against the Emperor from the first treatise, but makes it more central. John's attitude here poses interesting questions about his own sense of self-identity: who was he—the subject of the Caliph or the fearless servant of the Emperor?

The third treatise is different again. It adopts the simplified polemical argument of the second treatise, but then moves into an altogether more elevated key. After recalling one of the themes that underlie his *On the Orthodox Faith*, namely that as humans are twofold, material and spiritual, so too must the Christian Faith be, which brings God's message to human kind, John goes on to present a lengthy and systematic exposition of the nature of the icon, both its various kinds and how and by whom they are made, and follows this by a similarly systematic account of the meaning of veneration, *proskynesis*.

Florilegia

Each of the treatises concludes with a florilegium. Florilegia had become an important tool of polemical theology, particularly since the controversies that had led up to the Synod of Chalcedon. That synod had claimed the authority of "following the holy Fathers": florilegia consisted of extracts from the acknowledged Fathers, intended to clarify the nature of that patristic authority. Hitherto, florilegia had been principally concerned with issues of Christology; John's florilegia, attached to his treatises on the Divine Images, concerned the question of icons and their veneration, an issue that was soon to be regarded as a fundamentally Christological matter. However, to speak of "the florilegia" appended to these treatises obscures something important. There are really only two florilegia: the one attached to the first treatise, which is appended to the second with only minor modifications, and the one attached to the third treatise. The last is more like a normal florilegium, that is, a list of passages

from the Fathers collected together. The first is really something different. It is not "attached" to the first treatise; it is rather the conclusion of the first treatise, and in fact consists of a discussion of a list of passages, evoked by John in the defense of icons. Virtually every passage has a commentary by John, and the commentary, as we have seen, continues the argument of the treatise. The florilegium attached to the third treatise is really just a collection of passages, with scarcely any commentary (what commentary there is comes early on, and probably was inspired by his still using the earlier florilegia in compiling it). The passages collected in the florilegia concern: first, the importance and meaning of the image as such (many of these seem to have little to do directly with iconoclasm); secondly, passages that justify the veneration of images; thirdly, passages, mainly from the lives of the saints, that illustrate the place of icons in Christian devotion. These florilegia have had an odd fate. On the one hand, many manuscripts of the treatises against the iconoclasts do not include them at all (having translated them, I can understand the way in which copyists must have groaned at a long list of patristic citations). On the other hand, it is certain that these florilegia are an original part of the treatises, for immediately, in the eighth century itself, they were very popular and form one of the main sources for other iconophile florilegia that circulated in the eighth century and lie behind the patristic passages cited at the Seventh Ecumenical Synod of 787.[1]

Presentation and Translation

The present translation has been made from the critical text established by Dom Bonifatius Kotter OSB.[2] Earlier translations into

[1]Cf. Alexander Alexakis, *Codex Parisinus Graecus 1115 and Its Archetype*, Dumbarton Oaks Studies, 35 (Washington, DC: Dumbarton Oaks Research Library and Collection, 1996).

[2]Bonifatius Kotter (ed.), *Die Schriften des Johannes von Damaskos*, 5 vols., PTS 7, 12, 17 (= *On the Divine Images*), 22, 29 (Berlin-New York: Walter de Gruyter, 1969–88).

English were partial and often paraphrastic (nor were they independent: Anderson was a light revision of Allies).[3] This is a fresh translation of the whole of the three treatises (though in the translation of the patristic passages contained in the florilegia I have sometimes used existing translations, which are indicated in the footnotes and the bibliography). Even though there are considerable overlaps (which are indicated in the text at the head of each chapter, prefaced by "cf." in cases where the dependence is not entire), I have reproduced the whole of each treatise proper, for just as important as the arguments they contain is the form these arguments take in each treatise (in contrast, Kotter in his edition produces a kind of synopsis, which makes clear the interrelationship between the three treatises, though makes it difficult to read any one of them). In the case of the first and the third treatise, the florilegium is included as part of the treatise (as indicated above, this is particularly important for the first treatise); since the second florilegium is virtually the same as the first, I have simply added, as an appendix to the second treatise, the passages added (nothing was deleted). The existing translations are most selective in their translation of the florilegia; Mary Allies remarked "a few Testimonies have been suppressed as unsuitable or irrelevant," but they were presumably not thought "unsuitable or irrelevant" (to whom?) when they were painstakingly collected.[4]

The translation is meant to be accurate rather than literary (though I may well have failed even in that), and I have tried to preserve consistency between translations of similar passages in different treatises, to make comparison easier. Saint John Damascene, of course, used the Septuagint (LXX) Greek translation of the Old Testament. This is often different (both in order and content) from the

[3]Mary H. Allies (trans.), *St John Damascene on the Holy Images, followed by Three Sermons on the Assumption* (London: Thomas Baker, 1898); David Anderson (trans.), St John of Damascus, *On the Divine Images* (Crestwood, NY: St Vladimir's Semimary Press, 1980).

[4]Allies, *St John Damascene*, 115.

Hebrew version on which English Bibles are mostly based; Old Testament references are to the Septuagint, with LXX added if the Hebrew text is markedly different, and a reference given to the Hebrew text if this is enumerated differently (save in the case of the psalms, where one simply needs to remember that between psalms 10 and 146 the enumeration in the LXX are mostly one less than in the Hebrew enumeration, followed in most English Bibles); note also that 1–2 Samuel and 1–2 Kings are 1–4 Kingdoms in the LXX, and the books of Chronicles are called Paralipomena. I also have used square brackets to indicate editorial insertions.

Feast of the Transfiguration, 2002
Andrew Louth

Defense against those who attack the holy images by our Father among the Saints John Damascene

1 It is necessary for us, always conscious of our unworthiness, to keep silence and confess our sins before God, but since all things are good in their season, and I see the Church, which God built upon the foundation of the apostles and the prophets, Christ his Son being the head cornerstone, battered as by the surging sea overwhelming it with wave upon wave, tossed about and troubled by the grievous assault of wicked spirits, and Christ's tunic, woven from top to bottom, rent, which the children of the ungodly have arrogantly sought to divide, and his body cut to pieces, which is the people of God and the tradition of the Church that has held sway from the beginning, I do not believe it right to keep silence and bridle my tongue, paying attention to the threatening judgment that says: "if he shrinks back, my soul has no pleasure in him,"[1] and "if you see the sword coming and do not warn your brother, his blood I shall require at your hand."[2] Compelled to speak by a fear that cannot be borne, I have come forward, not putting the majesty of kings before the truth, but

[1] Heb 10:38, citing Hab 2:4 (LXX).
[2] Ezek 33:6, 8.

hearing David, the divine ancestor, say, "I spoke before kings and was not ashamed,"[3] goaded more and more to speak. For the word of a king exercises terror over his subjects. For there are few who would utterly neglect the royal constitutions established from above, who know that the king reigns upon earth from above, and as such the laws of kings hold sway.

2 Therefore, holding firm in thought to the preservation of the ordinances of the Church, through which salvation has come to us, as a kind of keel or foundation, I have brought my discourse to the starting point, as it were urging on a well-bridled horse. For it seems to me a calamity, and more than a calamity, that the Church, adorned with such privileges and arrayed with traditions received from above by the most godly men, should return to the poor elements, afraid where no fear was,[4] and, as if it did not know the true God, be suspicious of the snare of idolatry and therefore decline in the smallest degree from perfection, thus bearing a disfiguring mark in the midst of a face exceeding fair, thus harming the whole by the slightest injury to its beauty. For what is small is not small, if it produces something big, so the slightest disturbance of the tradition of the Church that has held sway from the beginning is no small matter, that tradition made known to us by our forefathers, whose conduct we should look to and whose faith we should imitate.

3 Therefore I entreat first the Lord Almighty, to whom everything is naked and laid open, about whom we speak, who knows the purity of my humble intention in this and the innocence of my purpose, to give me words when I open my mouth and to take up in his own hands the reins of my mind and to draw it to himself, making me to proceed in his presence on an straight path, neither declining to the seductive right nor knowing the clearly visible left—and together

[3]Ps 118:46.
[4]Ps 52:6.

with Him all the people of God, the holy nation, the royal priest-hood, with the good shepherd of Christ's rational flock, who repre-sents in himself the hierarchy of Christ, to receive my discourse with kindness, paying no attention to my little worth, nor expecting elo-quence in my words, for I am only too aware of my inadequacy, but rather considering the power of my arguments ("for the kingdom of heaven is not in word, but in power"[5]); for my purpose is not to con-quer, but to stretch out a hand to fight for the truth, a hand stretched out in the power of freewill. Calling on the help of the one who is truth in person, I will make a start on my discourse.

4 (cf. III.6) I know what the One who cannot lie said: "the Lord your God is one Lord,"[6] and "you shall venerate the Lord your God and him alone shall you worship,"[7] and "there shall be for you no other gods,"[8] and "you shall not make any carved likeness, of any-thing in heaven above or on the earth below,"[9] and "all who vener-ate carved [images] shall be put to shame,"[10] and "gods, who did not make heaven and earth, shall be destroyed,"[11] and these words in a similar manner: "God, who of old spoke to the fathers through the prophets, has in these last days spoken to us in his Only-begotten Son, through whom he made the ages."[12] I know the One who said: "This is eternal life, that they might know you, the only true God and Jesus Christ, whom you sent."[13] I believe in one God, the one begin-ning of all things, himself without beginning, uncreated, imperish-able and immortal, eternal and everlasting, incomprehensible, bodiless, invisible, uncircumscribed, without form, one being

[5]1 Cor 4:20.
[6]Deut 6:4.
[7]Deut 6:13.
[8]Deut 5:7.
[9]Deut 5:8.
[10]Ps 96:7.
[11]Jer 10:11.
[12]Heb 1:1–2.
[13]Jn 17:3.

beyond being, divinity beyond divinity, in three persons, Father and Son and Holy Spirit, and I worship this one alone, and to this one alone I offer the veneration of my worship. I venerate one God, one divinity, but also I worship a trinity of persons, God the Father and God the Son incarnate and God the Holy Spirit, one God. I do not venerate the creation instead of the creator, but I venerate the Creator, created for my sake, who came down to his creation without being lowered or weakened, that he might glorify my nature and bring about communion with the divine nature. I venerate together with the King and God the purple robe of his body, not as a garment, nor as a fourth person (God forbid!), but as called to be and to have become unchangeably equal to God, and the source of anointing. For the nature of the flesh did not become divinity, but as the Word became flesh immutably, remaining what it was, so also the flesh became the Word without losing what it was, being rather made equal to the Word hypostatically. Therefore I am emboldened to depict the invisible God, not as invisible, but as he became visible for our sake, by participation in flesh and blood. I do not depict the invisible divinity, but I depict God made visible in the flesh. For if it is impossible to depict the soul, how much more God, who gives the soul its immateriality?

5 (cf. III.7) But they say, God said through Moses the lawgiver, "You shall venerate the Lord your God and him alone shall you worship," and "you shall not make any likeness, of anything in heaven or on the earth." Brothers, those who do not know the Scriptures truly err, for as they do not know that "the letter kills, but the Spirit gives life,"[14] they do not interpret the spirit hidden beneath the letter. To these I might rightly say, the One who taught you this taught also what follows. Learn, how the lawgiver interprets this when he says in Deuteronomy, "And the Lord spoke to you from the midst of the fire; you heard the sound of his words and you did not see any likeness,

[14] 2 Cor 3:6.

but only a voice," and a little later, "take good heed to your soul, for you did not see a likeness on the day, when the Lord spoke to you on Horeb in the mountain in the midst of the fire. Beware lest you act lawlessly and make for yourselves a carved likeness, any image, a likeness of a male or a female, a likeness of any beast that is upon the earth, a likeness of any winged bird" and so on, and after a little, "Beware lest you look up in the sky and see the sun and the moon and the stars and all the order of heaven, and being led astray venerate them and worship them."[15]

6 (cf. II.8, III.7) You see that the single purpose of this is that one should not worship, or offer the veneration of worship, to creation instead of the Creator, but only to the One who fashioned all. Therefore everywhere it concerns worship by veneration. Again it says, "There shall be for you no other gods beside me, You shall not make for yourself a carved [image] nor any likeness, you shall not venerate them nor shall you worship them, for I am the Lord your God,"[16] and again "You shall tear down their altars, and break their pillars, and cut down their sacred groves, and burn up the carved [images] of their gods with fire, for you shall not venerate any other god,"[17] and a little later "you shall not make for yourself any gods of cast metal."[18]

7 (II.8, III.7) You see, how it was on account of idolatry that he prohibited the fashioning of images, and that it is impossible to depict God who is incommensurable and uncircumscribable and invisible. "For," it says, "you have not seen his form,"[19] just as also Paul, standing in the midst of the Areopagus, said, "Being then God's offspring, we ought not to think that the divine is like gold, or silver, or stone, a representation of human art and imagination."[20]

[15]Deut 4:12, 15–17, 19.
[16]Deut 5:7–9.
[17]Exod 34:13–14.
[18]Exod 34:17.
[19]Jn 5:37.
[20]Acts 17:29.

8 (cf. III.8) It was, therefore, for the Jews, on account of their slid-
ing into idolatry, that these things were ordained by law. To speak
theologically,[21] however, we, to whom it has been granted, fleeing
superstitious error, to come to be purely with God, and having rec-
ognized the truth, to worship God alone and be greatly enriched
with the perfection of the knowledge of God, and who, passing
beyond childhood to reach maturity, are no longer under a custo-
dian, have received the habit of discrimination from God and know
what can be depicted and what cannot be delineated in an image.
"For," it says, "you have not seen his form." What wisdom the legis-
lator has! How could the invisible be depicted? How could the
unimaginable be portrayed? How could one without measure or size
or limit be drawn? How could the formless be made? How could the
bodiless be depicted in color? What therefore is this that is revealed
in riddles? For it is clear that when you see the bodiless become
human for your sake, then you may accomplish the figure of a
human form; when the invisible becomes visible in the flesh, then
you may depict the likeness of something seen; when one who, by
transcending his own nature, is bodiless, formless, incommensu-
rable, without magnitude or size, that is, one who is in the form of
God, taking the form of a slave, by this reduction to quantity and
magnitude puts on the characteristics of a body, then depict him on
a board and set up to view the One who has accepted to be seen.
Depict his ineffable descent, his birth from the Virgin, his being bap-
tized in the Jordan, his transfiguration on Tabor, what he endured to
secure our freedom from passion, the miracles, symbols of his divine
nature, performed by the divine activity through the activity of the
flesh, the saving cross, the tomb, the resurrection, the ascent into
heaven. Depict all these in words and in colors. Do not be afraid, do
not fear; I know the different forms of veneration. Abraham vener-
ated the sons of Emmor, godless men suffering from ignorance of

[21]That is, to speak in the manner of St Gregory the Theologian. The first part of
this sentence follows *Hom.* 39.8.1–2 (ed. Moreschini, 162) quite closely.

God, when he acquired the cave as a double inheritance for a tomb.[22] Jacob venerated Esau his brother and Pharaoh the Egyptian, bowing in veneration over the head of his staff.[23] They venerated, they did not worship. Jesus[24] the son of Nave and Daniel venerated the angel of God, but they did not worship.[25] The veneration of worship is one thing, veneration offered in honor to those who excel on account of something worthy is another.

9 But since this discourse is about the image and its veneration, let us elucidate their meaning. An image is a likeness depicting an archetype, but having some difference from it; the image is not like the archetype in every way. The Son is a living, natural and undeviating image of the Father, bearing in himself the whole Father, equal to him in every respect, differing only in being caused. For the Father is the natural cause, and the Son is caused; for the Father is not from the Son, but the Son from the Father. For [the Son] is from him, that is the Father who begets him, without having his being after him.

10 There are also in God images and paradigms of what he is going to bring about, that is his will that is before eternity and thus eternal. For the divine is in every respect unchanging, and there is in it no change or shadow of turning. Saint Dionysius, who had great insight in matters divine, what belongs to God and what may be said about God, says that these are images and paradigms and predeterminations.[26] For in his will everything predetermined by him, that

[22]John is following Acts 7:16, which seems to conflate two accounts: Abraham's purchase of a cave as a tomb from Ephron, one of the Hittites, to whom he bowed down (or venerated: Gen 23:7), and the burial ground in which Joseph was buried, that had been purchased by Jacob from Emmor (Hamor in English Bibles: Gen 33:19–20).

[23]Esau: Gen 33:3; bowing over the head of his staff: Heb 11:21 (cf. Gen 47:31 LXX). In his encounter with Pharaoh, Jacob did not bow down, but blessed him: cf. Gen 47:7–10.

[24]Joshua, in English Bibles.

[25]Jos 5:14; Dan 8:17.

[26]Dionysius the Areopagite, *Divine Names*, 5.8 (ed. Suchla, 188).

will unfailingly come to pass, is designated and depicted before it comes to be, just as, if one wants to build a house, its form is described and depicted first in the mind.

11 Then again there are images of invisible and formless things, that provide in bodily form a dim understanding of what is depicted. For Scripture applies forms to God and the angels, and the same divine man[27] gives the reason when he says that if forms for formless things and shapes for shapeless things are proposed, someone might say that not the least reason is because our analogies are not capable of raising us immediately to intellectual contemplation but need familiar and natural points of reference. If then the divine Word, foreknowing our need for analogies and providing us everywhere with something to help us ascend, applies certain forms to those things that are simple and formless, how may not those things be depicted which are formed in shapes in accordance with our nature, and longed for, although they cannot be seen owing to their absence? For through the senses a certain imaginative image is constituted in the front part of the brain and thus conveyed to the faculty of discernment and stored in the memory. The divinely eloquent Gregory therefore says that the intellect, tiring of trying to get past all things corporeal, realizes its impotence;[28] but "the invisible things of God, since the creation of the world, have been clearly perceived through the things that have been made."[29] For we see images in created things intimating to us dimly reflections of the divine; as when we say that there is an image of the holy Trinity, which is beyond any beginning, in the sun, its light and its ray, or in a fountain welling up and the stream flowing out and the flood, or in our intellect and reason and spirit, or a rose, its flower and its fragrance.

[27]Idem, *Celestial Hierarchy*, 1.1.3 (ed. Heil, 8–9).
[28]Gregory Nazianzen, *Hom.* 28.13 (ed. Gallay, 128). Cf. *Images*, II.5, III.2, 21.
[29]Rom 1:20.

12 Again there are said to be images of the future, describing the things to come in shadowy enigmas, as the ark[30] foreshadows the holy Virgin Mother of God, as does the rod[31] and the jar;[32] and the serpent[33] the one who did away with the bite of the primordially evil serpent through the cross; or the sea, water, and the cloud the Spirit of baptism.[34]

13 Again there are said to be images of what is past, either the memory of a certain miracle, or honor, or shame, or virtue, or vice, for the benefit of those who behold them later, so that they may flee what is evil and be zealous for what is good. This kind of image is twofold: through words written in books, as God engraved the Law on tablets and ordered the lives of men beloved of God to be recorded; and through things seen by the sense of sight, as when he ordered the jar and the rod to be placed in the ark as a memorial.[35] So now we register the images and virtues of the past. Therefore, either destroy every image and establish laws against the One who ordered that these things should be, or receive each in the reason and manner fitting to each.

Having discussed the different forms of the image, let us now talk about veneration.

14 Veneration (bowing down) is a symbol of submission and honor. And we know different forms of this. The first is as a form of worship, which we offer to God, alone by nature worthy of veneration.[36] Then there is the veneration offered, on account of God who is naturally venerated, to his friends and servants, as Jesus the son of Nave and Daniel venerated the angel; or to the places of God, as

[30]The ark of the covenant: Exod 25:10–16.
[31]Aaron's rod: Num 17:8.
[32]The jar of manna: Exod 16:33.
[33]Moses' bronze serpent: Num 21:8; cf. Jn 3:14.
[34]Cf. 1 Cor 10:1–4.
[35]Heb 9:4.
[36]Cf. Gal 4:8.

David said, "Let us venerate in the place, where his feet stood";[37] or
to things sacred to Him, as Israel venerated the tabernacle and the
temple in Jerusalem standing in a circle around it, and then from
everywhere bowing in veneration towards it, as they still do now, or
to those rulers who had been ordained by Him, as Jacob venerated
Esau, made by God the elder-born brother, or Pharaoh, appointed
by God his ruler, and his brothers venerated Joseph.[38] And I know
that such veneration is offered to others as a mark of honor, as Abra-
ham venerated the sons of Emmor. Either, therefore, reject all ven-
eration or accept all of these forms with its proper reason and
manner.

15 Answer me this question. Is God one God? Yes, you say, as it
seems to me, one lawgiver. Why then does He decree what is contra-
dictory? For the cherubim are not outside creation. Why then does
he prescribe carved cherubim fashioned by human hands to over-
shadow the mercy seat? It is clear that it is impossible to make an
image of God or of anything like God, since he is uncircumscribable
and unimaginable, lest the creation be venerated in worship as God.
Since the cherubim are circumscribable, He prescribes the making
of an image of them prostrate before the divine throne, to over-
shadow the mercy seat; for it was fitting that the image of the divine
mysteries should shadow the image of the heavenly servants. And
what do you say about the ark, the jar and the mercy seat? Were they
not handmade? Not the work of human hands? Were they not fash-
ioned, as you put it, from unworthy matter? What of the whole tab-
ernacle? Was it not an image? Not a shadow and a copy? Therefore
the divine apostle says about the sacred things made in accordance
with the law: "These things serve a copy and shadow of the heavenly
sanctuary; for when Moses was about to erect the tabernacle, he was
instructed by God, saying, See that you make everything according

[37]Ps 131:7 LXX.
[38]Gen 42:6.

to the pattern which was shown you on the mountain."[39] But the law was not an image, but a foreshadowing of an image; therefore the same apostle says, "For the law having a shadow of the good things to come, not being itself the image of the realities."[40] If then the law prohibits images, while being itself a depiction of the image in advance, what shall we say? If the tabernacle is a shadow and the figure of a figure, how then can the law command that images be not drawn? But these things are not so, not at all. Rather, "there is a season for everything."[41]

16 (cf. II.14) Of old, God the incorporeal and formless was never depicted, but now that God has been seen in the flesh and has associated with human kind, I depict what I have seen of God. I do not venerate matter, I venerate the fashioner of matter, who became matter for my sake and accepted to dwell in matter and through matter worked my salvation, and I will not cease from reverencing matter, through which my salvation was worked. I do not reverence it as God—far from it; how can that which has come to be from nothing be God?—if the body of God has become God unchangeably through the hypostatic union, what gives anointing remains, and what was by nature flesh animated with a rational and intellectual soul is formed, it is not uncreated. Therefore I reverence the rest of matter and hold in respect that through which my salvation came, because it is filled with divine energy and grace. Is not the thrice-precious and thrice-blessed wood of the cross matter? Is not the holy and august mountain, the place of the skull, matter? Is not the life-giving and life-bearing rock, the holy tomb, the source of the resurrection, matter? Is not the ink and the all-holy book of the Gospels matter? Is not the life-bearing table, which offers to us the bread of life, matter? Is not the gold and silver matter, out of which crosses and tablets and bowls are fashioned? And, before all these things, is

[39]Heb 8:5.
[40]Heb 10:1.
[41]Eccles 3:1.

not the body and blood of my Lord matter? Either do away with rev-
erence and veneration for all these or submit to the tradition of the
Church and allow the veneration of images of God and friends of
God, sanctified by name and therefore overshadowed by the grace of
the divine Spirit. Do not abuse matter; for it is not dishonorable; this
is the view of the Manichees. The only thing that is dishonorable is
something that does not have its origin from God, but is our own
discovery, by the free inclination and turning of our will from what
is natural to what is unnatural, that is sin. If because of the law you
dishonor images and prohibit them as fashioned from matter, see
what Scripture says: "And the Lord spoke to Moses saying, See I have
called by name Beseleel the son of Ori the son of Hor from the tribe
of Judah. And I have filled him with the divine spirit of wisdom and
understanding and knowledge in every work to devise and to design
and to work in gold and silver and bronze and aquamarine and por-
phyry and spun scarlet and twisted flax and stonework and of car-
pentry for wood, to work in every craft. And I have also given him
Eliab the son of Achisamach for the tribe of Dan; and I have given
all of them intelligence in an understanding heart, and they will
make all that I have commanded you."[42] And again, "Moses said to
all the congregation of the sons of Israel, Hear this word which the
Lord has commanded, saying, Take from among you an offering to
the Lord. Whoever has a generous heart, let him offer the first-fruits
to the Lord, gold, silver, bronze, aquamarine, porphyry, scarlet twill
and twisted flax and goats' hair and rams' skin dyed red and skins
dyed aquamarine and acacia wood and oil for anointing and spices
for incense and carnelians and precious stones for engraving and for
the shoulder-piece and the robe. And let every one wise in heart
among you come and work everything, that the Lord has com-
manded, the tabernacle,"[43] and the rest, and after the other things
"he fastened both the stones of emerald together, enclosed in

[42]Exod 31:1–6 LXX.
[43]Exod 35:4–10.

settings of gold filigree, and engraved like the engravings of a signet,"[44] and again, "there were twelve stones with their names according to the names the sons of Israel; they were like signets, each engraved with its name, for the twelve tribes,"[45] and straightaway, "and he made the veil of the tabernacle of witness out of aquamarine and porphyry and spun scarlet and twisted flax, woven work of the cherubim."[46] Behold precious matter, which you regard as dishonorable! What is cheaper than colored goats' hair? Are not scarlet and porphyry and aquamarine merely colors? Look at the likeness of the cherubim. How therefore can you say that what the law orders to be made is prohibited by the law? If, because of the law, you prohibit images, watch that you keep the sabbath and are circumcised; for these the law unyieldingly commands. But know that if you keep the law, "Christ is no use to you; you who would be justified by the law, have fallen from grace."[47] Israel of old did not see God, "but we, with unveiled face, behold the glory of God."[48]

17 I say that everywhere we use our senses to produce an image of the Incarnate God himself, and we sanctify the first of the senses (sight being the first of the senses), just as by words hearing is sanctified. For the image is a memorial. What the book does for those who understand letters, the image does for the illiterate; the word appeals to hearing, the image appeals to sight; it conveys understanding. Therefore God ordered that the ark should be made of acacia wood and gilded within and without, and that the tablets, the rod, the golden jar containing manna should be placed in it as a memorial of what had happened and to prefigure what was to come.

[44]Exod 36:13 LXX; cf., in English Bibles, Exod 39:6.

[45]Exod 36:21 LXX; cf., in English Bibles, Exod 39:14.

[46]Exod 37:5 LXX; John's text is slightly different from the LXX, which reads "a work with cherubim woven in," which is closer to the Hebrew: cf., in English Bibles, Exod 36:8.

[47]Gal 5:2, 4.
[48]2 Cor 3:18.

And who will say that these images are not loudly sounding heralds? And these were not placed at the side of the tabernacle, but right in front of the people, so that those who saw them might offer veneration and worship to God who had worked through them. It is clear that they were not worshipping them, but being led by them to recall the wonders they were offering veneration to God who had worked marvels. For images were set up as memorials, and were honored, not as gods, but as leading to a recollection of divine activities.

18 And God ordered twelve stones to be taken from the Jordan, and he gave the reason; for he said, "so that, when your son asks you, what are these stones? you shall relate how the water of the Jordan failed at the divine command, and the ark of the Lord and all the people passed over."[49] How therefore shall we not depict in images what Christ our God endured for our salvation and his miracles, so that, when my son asks me, what is this? I shall say that God the Word became human and through him not only did Israel cross over the Jordan, but our whole nature was restored to ancient blessedness, through which that nature has ascended from the lowest parts of the earth beyond every principality and is seated on the very throne of the Father.

19 But then they say, Make an image of Christ and of his Mother who gave birth to God, and let that suffice. What an absurdity! You confess clearly that you are an enemy of the saints! For if you make an image of Christ, but in no wise of the saints, it is clear that you do not prohibit the image, but rather the honor due to the saints, something that no one has ever dared to do or undertake with such brazenness. For to make an image of Christ as glorified and yet spurn the image of the saints as without glory is to endeavor to show that the truth is false. "For I live,"[50] says the Lord, "and I shall glorify

[49]Cf. Jos 4:6–7.

[50]"As I live" is a favorite divine oath (usually prefacing a curse) in Ezekiel. The rest of the John's citation is not found in conjunction with the oath in Scripture.

those who glorify me,"[51] and the divine apostle, "So you are no longer a slave, but a son, and if a son, an heir of God through Christ,"[52] and "if we suffer together [with him], so that we are glorified together."[53] You are not waging a war against images, but against the saints. John the theologian, who leant on Christ's breast, therefore says, that "we shall be like him."[54] For just as iron plunged in fire does not become fire by nature, but by union and burning and participation, so what is deified does not become God by nature, but by participation. I am not speaking of the flesh of the incarnate Son of God; for that is called God immutably by hypostatic union and participation in the divine nature, not anointed by the energy of God as with each of the prophets, but by the presence of the the the whole of the one who anoints. Because by deification the saints are gods, it is said that "God stands in the company of gods, in the midst he discriminates between the gods,"[55] when God stands in the midst of the gods, distinguishing their several worth, as Gregory the Theologian interprets it.[56]

2 0 God ordered David to build him a house through his own son Solomon and to prepare his resting-place. Solomon built this and made cherubim, as the book of Kingdoms says, and covered the cherubim with gold and made engravings all round the walls in the form of cherubim and phœnixes[57] both inside and out—not, he said, on the sides, but "all round"—and also oxen and lions and pomegranates. Are not all the walls of the house of the Lord made much more valuable when adorned with the forms and images of saints, rather than animals and trees? Where is the declaration of the law: "You shall not make any likeness"? But Solomon, who was filled

[51]1 Kgd 2:30.
[52]Gal 4:7.
[53]Rom 8:17.
[54]1 Jn 3:2.
[55]Ps 81:1.
[56]Gregory Nazianzen, *Hom.* 40.6.24–5 (ed. Moreschini, 208).
[57]Or: palm trees. Cf. *Images* III, n. 221.

with wisdom, did not depict God, when he made likenesses of cherubim and lions and oxen—for this the law forbids—should not we, who do depict God, make images of the saints? For, just as then the temple and the people were sanctified with the blood of animals and the ashes of a heifer, now it is with the blood of Christ "who bore witness before Pontius Pilate"[58] and showed himself the firstfruits of the martyrs, and still the church is built by the holy blood of the saints, so as then the house of God was adorned with forms and images of animals, so now with saints who have prepared themselves in the spirit to be living and rational temples for the dwelling-place of the living God.

21 (cf. II.15) We represent Christ the King and Lord without divesting him of his army. For the saints are the army of the Lord. Let the earthly king divest himself of his own army, before he deprives his own King and Lord. Let him put aside the purple robe and the diadem, and then let him do away with those who fight most bravely against the tyrant and triumph over the passions. If they are heirs of God and co-heirs with Christ and partakers of the divine glory and kingdom, how shall not the friends of Christ be also fellow partakers on earth of his glory? "I do not call you slaves," says God, "you are my friends."[59] Should we then deprive them of the honor given them by the Church? O rash hand! O audacious opinion, rebelling against God and refusing to perform his commands! You do not venerate an image, nor do you venerate the Son of God, who is the living "image of the invisible God"[60] and his undeviating likeness.

I venerate the image of Christ, as God incarnate; of the mistress of all, the Mother of God, as the mother of the Son of God; of the saints, as the friends of God, who, struggling against sin to the point of blood, have both imitated Christ by shedding their blood for him,

[58]1 Tim 6:13.
[59]Cf. Jn 15:14–15.
[60]Col 1:15.

who shed his own blood for them, and lived a life following his footsteps. I set down in a record their brave feats and their sufferings, as ones who have been sanctified through them and as a stimulus to zealous imitation. And I do these things out of respect and veneration. "For the honor given to the image passes to the archetype,"[61] says the divine Basil. If you raise temples to the saints of God, then put up trophies to them as well. Of old a temple was not erected in the name of human beings, nor was the death of just ones celebrated, but they were buried, and anyone who touched a corpse was reckoned unclean, even Moses himself. Now the memorials of the saints are celebrated. The corpse of Jacob was buried, but that of Stephen is celebrated. Either, therefore, give up the festal memorials of the saints, which are contrary to the old law, or accept the images, which, you say, are contrary to the law. But it is impossible not to celebrate the memorials of the saints, for the choir of the holy apostles and the god-bearing fathers enjoins that these should take place. For from the time when God the Word became flesh, and was made like us in every respect save sin, and was united without confusion with what is ours, and unchangingly deified the flesh through the unconfused co-inherence of his divinity and his flesh one with another, we have been truly sanctified. And from the time when the Son of God and God, being free from suffering in his divinity, suffered in what he had assumed and paid our debt by pouring out a worthy and admirable ransom (for the Son's blood was appealing to the Father and worthy of respect), we have truly been set free. And from the time when he descended into Hades and preached forgiveness to the souls, who had been bound as captives there for all eternity, like sight to the blind, and, having bound the strong one by his excess of power, rose again and gave incorruption to the flesh that he had assumed from us, we have been made truly incorruptible. From the time when we were born of water and the Spirit, we have truly been adopted as sons and become heirs of God. Henceforth Paul calls the

[61]Basil the Great, *On the Holy Spirit*, 18.45 (ed. Pruche, 406).

faithful holy. Henceforth we do not mourn for the saints, but we celebrate their death. Henceforth, "we are not under the law, but under grace,"[62] "having been justified through faith,"[63] and knowing the only true God—"for the law is not laid down for the just"[64]—we are no longer enslaved by the elements of the law as children, but being restored to perfect manhood we are nourished with solid food, no longer prone to idolatry. For the law is good, like a lamp shining in a squalid place, but only until the day dawns. For already the morning star has risen in our hearts and the living water of the knowledge of God has covered the seas of the nations and all have come to know the Lord. "The old things have passed away, and behold everything is new."[65] The divine apostle therefore said to Peter, the supreme chief of the apostles, "If you, though a Jew, live like a Gentile and not like a Jew, how can you compel the Gentiles to live like Jews?"[66] and to the Galatians he wrote, "I testify to everyone who receives circumcision that he is bound to keep the whole law."[67]

22 Of old, therefore, those who did not know God were enslaved by those who by nature were not gods, but now, knowing God or rather known by God, how shall we turn again to the weak and beggarly elements?[68] I have seen the human form of God, "and my soul has been saved."[69] I see the image of God, as Jacob saw it, if in another way. For he saw an immaterial image, proclaiming beforehand what was to come to the immaterial eyes of the intellect, while I have seen the image of one seen in the flesh, that enkindles the memory. The shadow of the apostles, their handkerchiefs and

[62]Rom 6:14.
[63]Rom 5:1.
[64]1 Tim 1:9.
[65]2 Cor 5:17.
[66]Gal 2:14.
[67]Gal 5:3.
[68]Gal 4:8–9.
[69]Gen 32:31 LXX. Jacob's words in context are probably better translated "and my life has been preserved," but I think the above translation expresses John's own meaning.

aprons,[70] drove away diseases, and put demons to flight; how shall the shadow and image of the saints not be glorified? Either abolish the veneration of everything material, or do not innovate, "neither remove the ancient boundaries, set in place by your fathers."[71]

23 (cf. II.16). Not only has the ordinance of the Church been handed down in writings, but also in unwritten traditions. Therefore the divine Basil says in the twenty-seventh chapter of his thirty chapters on the Holy Spirit to Amphilochius, word for word, thus:

> Of the dogmas and preachings preserved in the Church, some we have from the written teaching, others we received from the tradition of the Apostles, handed down to us in secret, both of them having the same force for piety. No one who has the least experience of the laws of the Church will object to these, for if we try to dismiss that which is un-written among the customs as of no great authority, then without noticing it we shall damage the Gospel.[72]

These are the words of Basil the Great. For whence do we know the holy place of the skull, the memorial of life? Have not children learnt it from their fathers without anything being written down? For it is written that the Lord was crucified in the place of the skull and buried in a tomb, that Joseph had hewn in a rock; but that these are the places now venerated we know from unwritten tradition, and there are many other examples like this. What is the origin of the threefold [immersion in] baptism? Whence praying facing the East? Whence the tradition of the mysteries?[73] Therefore the divine

[70]The shadow of Peter: Acts 5:15; the handkerchiefs and aprons of Paul: Acts 19:12.
[71]Prov 22:28: a favorite quotation of John's, quoted at the end of the first chapter of *On the Orthodox Faith*.
[72]Basil the Great, *On the Holy Spirit*, 27.66 (ed. Pruche, 478–80).
[73]Or sacraments. These are the examples Basil cites in the rest of the chapter from *On the Holy Spirit*, quoted above.

apostle says, "So then, brethren, stand firm and hold to the traditions which you were taught by us, either by word of mouth or by our letters."[74] Since many such things have been handed down in unwritten form in the Church and preserved up to now, why do you split hairs over the images?

24 (cf. II.17) The practices that you mention do not make our veneration of images loathsome, but those of the idolatrous Greeks.[75] It is not necessary, on account of pagan abuse, to abolish our pious practice. Enchanters and sorcerers practice exorcism, the Church also exorcizes catechumens; but they call upon demons, while the Church calls upon God against demons. Greeks dedicate images to demons and call them gods, while we [dedicate images] to the true God incarnate and the servants and friends of God and drive away the hosts of the demons.

25 (cf. II.18) If you say that the divine and wonderful Epiphanius clearly prohibited these images, then first the work in question is perhaps spurious and forged, being the work of one and bearing the name of another, which often happens. Secondly, we know that the blessed Athanasius objected to putting the relics of the saints in a sarcophagus, ordering rather that they should be buried beneath the earth, wanting to abolish the absurd custom of the Egyptians, who do not bury their dead beneath the earth, but place them on beds and pallets. Perhaps, if we grant that the work is his, Epiphanius the Great wanted to correct a similar practice by forbidding the making of images. However, there is the witness of the divine Epiphanius' own church, that his purpose was not to abolish images, for it has been decorated with images up to our own time. Thirdly, an isolated instance does not make a law for the Church, "for one

[74]2 Thess 2:15.

[75]For John, as for any Christian Byzantine, "Greek" (*hellēn*) meant "pagan." The word translated "idolatrous" literally means "god-making."

swallow does not make a spring,"[76] as Gregory the Theologian says, and the truth declares. Nor can one word overthrow a tradition of the whole Church, which stretches from one end of the earth to the other.

26 Receive, therefore, the settled teaching of both scriptural and patristic practices, because, if Scripture says, "the idols of the nations are silver and gold, the works of human hands,"[77] it does not therefore prevent the veneration of inanimate things or the works of human hands, but only of images of demons.

27 It is said, therefore, that the prophets venerated angels and human beings and kings and godless men and even a rod. And David says, "And venerate the footstool of his feet."[78] And Isaiah, speaking in God's person, says, "Heaven in my throne, and the earth the footstool for my feet."[79] It is clear to everyone, I suppose, that heaven and earth are created. Moses and Aaron, too, with all the people worshipped things made by hand. Therefore, Paul the golden cicada of the Church says in his letter to the Hebrews, "Christ then, having appeared as a high priest of the goods things to come, through the greater and more perfect tabernacle not made by hands, that is, not of his creation,"[80] and again, "for Christ has entered, not into a sanctuary made with hands, a copy of the true one, but into heaven."[81] Thus the former sanctuary, the tabernacle and everything in it, was made with hands; and that it was venerated, no one denies.

[76]A proverb, found in Aristotle (*Nicomachean Ethics* I.7.16) and Gregory Nazianzen (*Hom.* 39.14 [ed. Moreschini, 182], who uses it, as does John, to illustrate the principle that an isolated instance does not make a law for the Church). The English proverb that "one swallow does not make a summer" reflects the more northerly climate of England.

[77]Ps 113:12.
[78]Ps 98:5.
[79]Isa 66:1.
[80]Heb 9:11.
[81]Heb 9:24.

28 (II.24) Saint Dionysius the Areopagite, from the letter to Titus:[82]

It is necessary that, contrary to the crowd's prejudice against them, we should make the sacred journey into the sacred symbols and not dishonor these things that are the offspring and impressions of divine tokens and manifest images of ineffable visions beyond nature.

29 (II.25) *Comment*: Look how he says that we are not to despise the images of what is honorable.

30 (II.26) The same, from *On the Divine Names*:[83]

Into this have we been initiated: now analogously, through the divine veils of the scriptural and priestly traditions, [God's] love for human kind[84] covers intelligible things by that which can be perceived by the senses and things beyond being by the things that are, and provides forms and figures for what is formless and without figure, and makes manifold and gives form to simplicity that is beyond nature and shape in a multitude of separate symbols.

31 (II.27) *Comment*: If it belongs to [God's] love for human kind to provide forms and figures for what is formless and without figure and for what is simple and without shape in accordance with our analogy, how then should not we form images analogous to us of what we see in forms and shapes to arouse our memory and from memory arouse zeal?

32 (II.28; III.44) The same, from *On the Ecclesiastical Hierarchy*:[85]

But the beings and orders that are above us, of which we have already made sacred mention, are bodiless, and their hierarchy is

[82]Dionysius the Areopagite, *ep.* 9.2 (ed. Ritter, 199).
[83]Idem, *On the Divine Names*, 1.4 (ed. Suchla, 114).
[84]*philanthropia.*
[85]Dionysius the Areopagite, *On the Ecclesiastical Hierarchy* 1.2 (ed. Heil, 65)

intelligible and transcends the cosmos. Let us see our hierarchy, in a way that bears analogy with us, made manifold by a multitude of symbols of things perceived by the senses, by which we ascend hierarchically, according to our measure, to the single-formed deification, to God and to divine virtue, those [beings] understanding, as intellects, in a way permitted to them, while we ascend by means of images perceived through the senses to the divine contemplations.

33 (II.29; cf. III.45) *Comment*: If, in a way that bears analogy with us, we are led by images perceived through the senses to divine and immaterial contemplation and, out of love for human kind, the divine providence provides figures and shapes of what is without shape or figure, to guide us by hand, so to say, why is it unfitting, in a way that bears analogy with us, to make an image of one who submitted to shape and form and out of love for human kind was seen naturally as a man? A story has come down to us by tradition: Abgar, the prince of Edessa, ardently burning with divine love at the fame of the Lord, sent ambassadors to beg for a visitation. If he declined to come, he commanded that a likeness be fashioned of him by an artist. When he who knows everything and can do everything learnt this, he took a strip of cloth and lifted it to his face, marking it with his own form. The cloth survives to this day.[86]

34 (II.30; III.46) Saint Basil, from his homily on the blessed Barlaam the Martyr, which begins: "First the death of the saints . . .":[87]

Rise up now for me, O radiant painters of athletic achievements, and magnify the mutilated image of the general by your arts. The context in which he was crowned, described more dimly by me, you

[86]The story of Abgar of Edessa is first found in Eusebius' *Church History* (I.13), though the mention of a portrait on a cloth (by tradition the *Mandylion*) only goes back to the fifth-century *Doctrine of Addai*. The story appears in much the same form in John Damascene's *On the Orthodox Faith* 89. Oddly, it is omitted from the later form of the florilegium that John appended to the third treatise.

[87]Basil, *Homily on Barlaam the Martyr* (PG 31.489A4-B4), also cited at Nicæa II.

make radiant with the colors of your wisdom. Overwhelmed by you, I will refrain from describing the martyr's deeds of valor. Beaten by your strength, I rejoice today in such a victory. I see the struggle depicted most exactly by you, with his hand in the fire; I see the combatant, radiant with joy, depicted in your image. Let the demons howl, as they are now struck down by the valiant deeds of the martyrs now manifest in you. Let the burning hand be once again shown as victorious over them. May Christ, the judge of the contest, inscribe them on his list, to whom be glory to the ages.

35 (II.31; III.48) The same, from the thirty chapters to Amphilochios on the Holy Spirit, chapter 17:[88]

Because the image of the emperor is called the emperor, yet there are not two emperors, for neither is the power divided nor the glory shared. For as the principle and authority that rules over us is one, so also is the praise that we offer one and not many, because the honor offered to the image passes to the archetype. What the image is by imitation here below, there the Son is by nature. And just as with works of art the likeness is in accordance with the form, so with the divine and incomposite nature the union is in the communion of the divinity.

36 (II.32) *Comment*: If the image of the emperor is the emperor, and the image of Christ is Christ, and the image of a saint is a saint, then the power is not divided nor the glory shared, but the glory of the image becomes that of the one depicted in the image. The demons are alarmed at the saints, and flee from their shadow; and the image is a shadow, and I make this to exorcize the demons. If you say that God ought only to be apprehended spiritually, then take away everything bodily, the lights, the fragrant incense, even vocal prayer, the divine mysteries themselves that are celebrated with

[88]Idem, *On the Holy Spirit*, 18.45.15–23 (ed. Pruche, 406), also (partially) cited at Nicæa II.

matter, the bread, the wine, the oil of chrismation, the form of the cross. For these are all material: the cross, the sponge, the reed, the lance that pierced the life-bearing side. Either take away the reverence offered to all these, as impossible, or do not reject the honor of the images. Divine grace is given to material things through the name borne by what is depicted. Just as the purple dye and the silk and the garment that is woven from them simply by themselves have no honor, but if an emperor wears it, his clothing shares in the honor that belongs to the one wearing it. So material things, on their own, are not worthy of veneration, but if the one depicted is full of grace, then they become participants in grace, on the analogy of faith.[89] The apostles saw the Lord with their bodily eyes, and others saw the apostles, and others the martyrs. And I long to see them in soul and body, and to possess the medicine that wards off evil, for I am made with a double nature,[90] and seeing, I venerate what I see, not as God, but as an honorable image of those worthy of honor. You, perhaps, are exalted and immaterial and have come to transcend the body and as fleshless, so to speak, you spit with contempt on everything visible, but I, since I am a human being and wear a body, I long to have communion in a bodily way with what is holy and to see it. Condescend to my lowly understanding, O exalted one, that you may preserve your exaltedness. Christ accepted my longing for him and for those who belong to him. For the master rejoices, when the prudent servant is praised, as Basil the Great said in [his homily in] praise of the forty martyrs.[91] Consider what he said in celebration of Gordius, celebrated in song:

37 (II.33) Saint Basil, from the homily on Gordius the martyr:[92]

Let the people rejoice with spiritual joy at the simple remembrance of the deeds achieved by the just, urged to zeal and to

[89]Cf. Rom 12:6.
[90]Cf. *Images*, III.12.
[91]Cf. Basil, *Homily on the 40 Martyrs of Sebaste* (PG 31.508B). Cf. *Images*, I.42.
[92]Idem, *Homily on Gordius the Martyr* (PG 31.492A, 492B).

imitation of the good people from whom they hear [these things]; for the story of men who conduct their lives well is a kind of light on the path of life to those who are being saved.

And a little further on:

Just as, when we relate the lives of those who are conspicuous in reverent life, we glorify first the master through the servants, and praise the just, whom we know through their witness, and make the people rejoice through hearing of the good.

38 (II.34) *Comment*: Behold, as the glory of God, the praise of the saints, for the memory of the saints constitutes the joy and salvation of the people. Why, therefore, do you take this away?[93] For, as the same divine Basil says, memory comes about through word and images.

39 (II.35) From the same homily on Gordius the martyr:[94]

For just as illumination automatically comes from fire and fragrance from myrrh, so also something profitable follows necessarily from good deeds. And it is no small thing accurately to grasp the truth of what is past, for the memory that comes down to us and preserves the manly virtue of a man in his struggles, is dim. How then do those resemblances that are made amongst us by painters seem? For, since they copy images from images, they as often as not depart from the archetypes, and there is no small danger that we, if we turn away from the very sight of things themselves, will diminish the truth.

40 (II.36) And at the end of the same homily:[95]

For just as those who continually behold the sun are always amazed, in the same way we have a perpetually fresh memory of that man.

[93]This question suggests that John saw iconoclasm as involving an attack on the cult of the saints in general; Theophanes make the same association (see Theophanes, *Chronicle*, AM 6218; ed. de Boor 406; Mango 561). Cf. *Images*, I.19.

[94]Basil, *Homily on Gordius the Martyr* (493A).

[95]Ibid. (508A).

41 (II.37) *Comment:* It is clear that we continually behold [him] through word of mouth and images.

42 (II.38) And in the homily on the Forty most-honored Martyrs he says these things:[96]

How can one who loves the martyrs ever have enough of the memory of the martyrs? Therefore the honor shown to the good servants by their fellow servants is a proof of their good disposition towards their common Lord.

And again:

Genuinely blessed are those who bear witness[97] [to the martyrs], in order that they may become martyrs by their free will and turn out worthy of the same praises as theirs, without persecution, without fire, without scourgings.

43 (II.39) *Comment:* Why therefore do you debar me from the honor of the saints and begrudge me salvation? That he knows that the shape expressed through colors is linked to the word, listen to what he says a little later:

44 (II.40) Basil:[98]

Come together in our midst, as we set forth the excellent deeds of these men in a homily, drawing a lesson from them for the common benefit of those present, demonstrating them to all, as in a picture.

45 (II.41) *Comment:* Do you see how the function of image and word are one? "As in a picture," he says, "we demonstrate by word."

46 (II.42; III.47) And again there are these words:[99]

Moreover both writers of words and painters many times describe clearly human deeds of valor in war, the former adorning

[96]Basil, *Homily on the 40 Martyrs of Sebaste* (PG 31.508B).
[97]There is a play on words here: the Greek for witness and martyr is the same.
[98]Basil, *Homily on the 40 Martyrs of Sebaste* (508CD).
[99]Ibid. (508D–509A).

them with rhetoric, the latter inscribing them on tablets, and both arousing many to deeds of excellence. For what the word of a story makes present through hearing, the very same is shown silently in a picture through imitation.

47 (II.43) *Comment:* What could demonstrate more clearly than these passages, that images are books for the illiterate and silent heralds of the honor of the saints, teaching those who see with a soundless voice and sanctifying the sight? I may not have many books, nor have much time to read, but, strangled with thoughts, as if with thorns, I come into the common surgery of the soul, the church; the luster of the painting draws me to vision and delights my sight like a meadow and imperceptibly introduces my soul to the glory of God. I have seen the perseverance of the martyr, the recompense of the crowns, and as if by fire I am eagerly kindled to zeal, and falling down I venerate God through the martyr and I receive salvation. Have I not heard the same God-bearing Father saying, in his homily on the beginning of the Psalms, that "the Holy Spirit, knowing that the human race is lazy and moved with difficulty to virtue, mixed melody with the singing of psalms"?[100] What do you say? Shall I not paint in words and in colors the martyrdom of the martyrs and embrace with eyes and lips "what is wonderful to angels and the whole creation, painful to the devil and fearful to demons," as the same beacon of the Church said?[101] Or his words at the end of the homily in which he praises the Forty Martyrs:[102]

O holy chorus, O sacred condition, O unbroken phalanx, O common guards of the human race, good partakers of oversight, fellow-workers with prayers, most powerful ambassadors, stars of the inhabited world, flowers of the Church (I mean, both spiritual and

[100]Basil, *Homily on Psalm 1* (PG 29.212B).

[101]Basil, *Homily on Gordius the Martyr* (PG 31.501B).

[102]Basil, *Homily on the 40 Martyr of Sebaste* (PG 31.524C). One manuscript from the monastery of Dionysiou on the Holy Mountain, containing the florilegium of Treatise II, gives a much longer quotation from this homily.

temporal)! The earth did not hide you, but heaven received you. The gates of paradise were opened to you, a sight worthy of the army of angels, worthy of patriarchs, of prophets, of the just.

48 (II.44) *Comment*: How should I not long to see what the angels long to see?[103] In unison with this is what his brother, the like-minded Gregory, Bishop of Nyssa, says:

49 (II.45) Saint Gregory, bishop of Nyssa, from the supplement,[104] that is *On the Creation of Human Kind*, chapter 4:[105]

Just as the custom is that those who fashion images of rulers, as well as expressing their features, express the imperial dignity by garments of purple, and it is customarily called both image and emperor, so too human nature, since it is fashioned to rule everything else, is set up as a kind of living image, participating in its archetype in both dignity and name.

50 (II.46) The same, from the fifth chapter of the same work:[106]

The divine beauty is not made resplendent in a certain external figure or fortunate shape through certain beautiful colors, but is beheld in the ineffable blessedness of virtue. Just as painters transfer human forms on to tablets by means of certain colors, applying corresponding paints by imitation, so that the beauty of the archetype is transferred with accuracy to the likeness . . .

51 (II.47) *Comment*: See, since "the divine beauty is not made resplendent in a certain external figure through certain beautiful colors," it is therefore not depicted, while the human form is transferred to tablets by means of colors. If then the Son of God came to

[103]The same manuscript from Dionysiou includes here a long quotation from St Basil's *Against Sabellians and Arius and Anomœans*.
[104]Gregory of Nyssa's *On the Creation of Human Kind* was often thought of as a supplement to St Basil's commentary on the six days of creation, his *Hexaemeron*.
[105]Gregory of Nyssa, *On the Creation of Human Kind* 4 (PG 44.136C).
[106]Ibid. 5 (137A).

be in human form, taking the form of a servant, and coming to be in human likeness, and being found in figure as a human being,[107] how can he not be depicted? And if it is customary "to call the image of an emperor emperor" and "the honor offered to the image passes to the archetype," as the divine Basil says, how is it that the image is not honored and venerated, not as God, but as the image of God made flesh?

52 (II.48; III.50) From the homily of Saint Gregory of Nyssa, preached at Constantinople, on the divinity of the Son and the Spirit, and concerning Abraham, homily 44, which begins: "Just as those who love to behold such things are affected by meadows decked with flowers . . .":[108]

First then the father binds his child. I have often seen images of this tender scene in pictures and I have not been able to pass from seeing it without tears, so skillfully does the artist bring this story to my sight. Isaac is before us, crouching on his knee before the altar, with his hands tied behind his back; [his father] has seized him from behind with his knee bended, and with his left hand grasping the child's hair he pulls him towards himself and bends over the face that looks up to him piteously, and with a sword in his right hand he proceeds directly to the sacrifice. The edge of the sword has already touched his body, and then there comes to him a voice from God forbidding the deed.

53 (II.49; III.51) Saint John Chrysostom, from his interpretation of the Epistle to the Hebrews:[109]

In a certain way the first is an image of the second, Melchisedek [an image] of Christ, just as one might say that a sketch of a picture

[107]Cf. Phil 2:7.

[108]Gregory of Nyssa, *On the divinity of the Son and the Holy Spirit* (ed. Rhein, 138–9); cited at Nicæa II.

[109]John Chrysostom, passage unidentified (cf., however, *Homily* 12 *on Hebrews*, ed. Field, vol. 7, 150f.).

is a shadow of the picture in colors; therefore the law is called a shadow, grace truth, and reality what is to come. So the law and Melchisedek are preparatory sketches of the picture in colors, and grace and truth are that picture in colors, while reality belongs to the age to come, just as the Old [Testament] is a type of a type, and the New [Testament] a type of reality.

54 (II.50) Leontius of Neapolis in Cyprus, from his treatise against the Jews on the veneration of the Cross of Christ, the icons of the saints, and other matters, and on the relics of the saints:[110]

If you accuse me again, O Jew, saying, that I venerate the wood of the Cross as God, why do you not accuse Jacob of bowing in veneration over the head of his staff? But it is clear that in honoring the wood he did not venerate it, but venerated Joseph through the wood,[111] just as we [venerate] Christ through the Cross, but do not glorify the wood.

55 (II.51) *Comment*: If therefore we venerate the form of the Cross, making an image of the Cross from some kind of matter, how is it that we should not venerate the image of the Crucified One?

56 (II.52) And again from the same Leontius:

Since Abraham venerated the impious men who sold him the tomb and bowed his knee to the ground, but did not venerate them

[110]This citation, and those that follow, from Leontius of Neapolis' "Treatise against the Jews" appear in somewhat different forms in the florilegium attached to the third of John's treatises against the iconoclasts, and as cited in the *acta* of Nicæa II; otherwise the treatise has been lost. The various versions are brought together for comparison by H.G. Thümmel, *Die Frühgeschichte der ostkirchlichen Bilderlehre. Texte und Untersuchungen zur Zeit vor dem Bilderstreit*, (Berlin: Akademie Verlag, 1992), 340–53. The different versions present several puzzles, not least the fact that some appear to come from a dialogue between a Christian and a Jew, others from a treatise against the Jews. Although this treatise by Leontius is lost, other works of his survive: a couple of sermons and *Lives* of St John the Almsgiver, St Symeon the Fool and St Spyridon (though the version that survives of this latter may only be based on Leontius' version).

[111]Cf. Gen 47:31; Heb 11:21; *Images*, III.36.

as gods; and again Jacob blessed the impious Pharaoh who was an idolater, but did not bless him as god; and again, he fell down and venerated Esau, but did not venerate him as god.[112]

And again:

How is it that God commanded you to venerate the earth and the mountains? For he said, "Exalt the Lord our God and bow in veneration to his holy mountain. And bow in veneration before the footstool of his feet, for he is holy," that is, to the earth. "Heaven is my throne," he says, "earth is the footstool of my feet," says the Lord.[113] How is it that Moses venerated Iothor, who was an idolater, and Daniel Nabuchodonosor?[114] How can you accuse me of honoring and venerating those who honor and venerate God? Tell me, is it not fitting to venerate the saints rather than stone them, as you do? Is it not fitting to venerate them rather than overthrow them and cast down your benefactors into a cistern of mire?[115] If you loved God, you would certainly honor his servants. And if the bones of the just are unclean, how is it that the bones of Jacob and Joseph were transported with all honor from Egypt?[116] How was the dead man who touched the bones of Elisseus immediately raised up?[117] If God works miracles through bones, it is very clear that he can also do so through images and stones and many other things, just as also it happened with Elisseus, who gave his own staff to his servant and told him to go and through it raise up the child of the Shunamitess.[118] And Moses checked Pharaoh with his staff and divided the sea and made water sweet and broke the rock asunder and made water flow out.[119] And Solomon said, "Blessed is the wood, through

[112]Cf. Gen 23:7–12; 47:7, 10; 33:3; *Images*, I.8.

[113]Cf. Ps 98:5; Isa 66:1; *Images*, I.27.

[114]Cf. Exod 18:7; Dan 2:46. In English Bibles, Iothor and Nabuchodonosor appear as Jethro and Nebuchadnezzar.

[115]Cf. Jer 45:6 (LXX; English versions: 38:6).

[116]Cf. Gen 50:13, 25.

[117]Cf. 4 Kgds [2 Kgs] 13:21. In English Bibles Elisseus appears as Elisha.

[118]Cf. 4 Kgd 4:29.

[119]Cf. Exod 7–10; 14:16; 15:25; 17:6.

which salvation comes."[120] And Elisseus threw wood into the Jordan and brought up the axe-head.[121] And there is the "tree of life"[122] and the "plant Sabek," that is, "of forgiveness."[123] And Moses lifted up the serpent on a wooden pole and gave life to the people;[124] and by the wooden rod blossoming in the tabernacle the priesthood was ratified.[125] But equally you will tell me, O Jew, that everything in the tabernacle of witness God ordered Moses to make; and I will say to you that Solomon made many, varied things, both carved and in cast metal, in the temple, which God had not ordered him to make,[126] nor did the tabernacle of witness possess these things, neither the temple, which God showed to Ezekiel, and Solomon was not condemned for this; for he fashioned such forms to the glory of God, just as we do. You, too, used to have many different images and signs for the remembrance of God, before you were deprived of them because of your folly, namely, the Mosaic staff, the divinely-engraved tablets, the bush bedewed with fire, the rock dry yet giving water, the manna-bearing ark, the altar containing divine fire, the golden plate bearing the divine name, the ephod revealing God, the God-enshrouded tabernacle.[127] And if you overshadowed[128] all these things by day and night, saying, Glory to you, the only God who

[120]Wisd 14:7 (which reads "justice" instead of "salvation").

[121]Cf. 4 Kgd 6:6.

[122]Cf. Gen 2:9.

[123]Gen 22:13 LXX reads "the plant Sabek" for the thicket in which the ram, to be sacrificed instead of Isaac, was caught. The *catenæ* on Genesis preserve extracts from several patristic commentators (Eusebius of Emesa, Diodore of Tarsus, Procopius of Gaza, Severus of Antioch), who interpret Sabek as meaning "remission" or "forgiveness," doubtless deriving this from the root SBQ, which in Aramaic and Syriac means to forgive.

[124]Cf. Num 21:8f.

[125]Cf. Num 17:23 (English Bibles: 17:8). Cf. also the above examples about Elisseus and Moses with *Images*, I.22.

[126]Cf. 2 Chron 3–4.

[127]Almost all these adjectives are coinages of Leontius.

[128]It is not clear to me what this means; a very slight emendation (*kataskeuazou* for *kataskiazou*) would give the reading: "If you fashioned all these things by day and night . . ."

rules over all, who through all these things worked marvels in Israel, if through all these things belonging to the Law, which you once used to have, falling down you venerated God, you would see that veneration is offered to God through images.

And a little further on:

For if anyone purely loves a friend or a king or above all a benefactor, and if he beholds his son, or his staff, or his throne, or his crown, or his house, or his slave, he notices them and through these things greets and honors the benefactor, king, and above all God. For now, I tell you again, you, too, used to make Mosaic and prophetic images, and daily you venerated their master, God, in them. Whenever then you see the children of Christians venerating the Cross, know that they offer veneration to the crucified Christ and not to wood. Since if they reverenced the nature of wood, they would certainly be obliged to venerate trees and groves, just as you, Israel, once venerated these, saying to the tree and the stone, "you are my god, and you gave me birth."[129] We do not speak thus to the Cross or the forms of the Saints; for they are not our gods, but open books, manifestly set in place in the churches and venerated for the remembrance of God and his honor. For one who honors the martyr honors God, for whom the martyr bore witness; one who venerates the apostle of Christ venerates the one who sent him; and one who falls down before the mother of Christ [does so] evidently, because he offers honor to her son. For no one is God, save the one acknowledged in Trinity and Unity and worshipped as One.

57 (II.53) *Comment:* Is this the faithful interpreter of the words of the blessed Epiphanius, who adorned the island of the Cypriots with his own words, or those who speak from their own hearts? Hear also Severian, bishop of Gabala, and what he says:

[129]Jer 2:27.

5 8 (II.54, III.52) Severian, bishop of Gabala,[130] from the homily on the dedication of the Cross:[131]

How does the image of the accursed one bring life to our forefathers?

And a little further on:

How does the image of one accursed bring salvation to a people storm-tossed by misfortune? Now would it not be more credible to say: If any of you is bitten, look to the heaven above, to God, or into the tabernacle of God, and be saved? But passing over these, he fixes only on the image of the Cross. Why therefore did Moses do these things, when he said to the people, "Do not make for yourselves anything carved or of cast metal or a likeness of anything, whether in heaven above or in the earth beneath or in the waters under the earth"?[132] But why do I utter these things to someone ungrateful? Tell me, O most faithful servant of God, do you make what you forbid? Do you fashion what you overthrow? You who say "You shall not make anything carved," who overturned the molten calf, do you fashion a serpent in bronze? And this not secretly, but openly, known to all? But those things, he says, I laid down by law, that I might cut off the occasions of irreverence and lead the people from all apostasy and worship of idols; but now I cast a serpent usefully for a prefiguration of the truth. And just as I established the tabernacle and everything in it and spread out in the sanctuary the cherubim, a likeness of things invisible, as a type and shadow of things to come, so I set up the serpent for the salvation of the people, that through their experience of these things they might be prepared beforehand for the image of the sign of the Cross and upon it the Savior and Redeemer. And that this explanation is entirely without deceit, beloved, hear the Lord confirming this when he said, "And just as

[130]Severian was bishop of Gabala in the early fifth century, and was one of the leading opponents of St John Chrysostom at the Synod of the Oak (AD 403).

[131]From Severian's *Homily on the Serpent* (PG 56.499–516).

[132]Exod 20:4.

Moses lifted up the serpent in the desert, so must the Son of man be lifted up, that everyone who believes in him may not perish, but have eternal life."[133]

59 (II.55): *Comment*: Understand how he said that it was to deter the people who were unstable and ready for idolatry that he laid down a law against making any likeness, and that the raised up serpent was an image of the passion of the Lord.

60 (II.56, III.53): That the invention of images is nothing new, but an ancient practice, known and familiar to the holy and elect Fathers, listen to this: It is written in the life of Basil the Blessed by his disciple and successor in the see, Helladius, that the saint was standing in front of an icon of Our Lady, in which there was depicted a figure of the ever-praised martyr, Mercurius; he stood, praying for the overthrow of the most godless and apostate tyrant, Julian. From which icon he learnt this revelation: for he saw that for a little while the martyr disappeared, and not long afterwards [he reappeared] holding a blood-stained spear.[134]

61 (II.57, III.54): In the *Life of John Chrysostom* it is written in these very words:[135]

The blessed John loved very much the epistles of the most wise Paul.

[133]Jn 3:14–15.

[134]There is no other evidence that Helladius wrote a *Life* of St Basil the Great, though he was his successor in the see of Cæsarea. The *Life of Basil* by his friend Amphilochius has a similar story, but there is no mention of an icon. The same story, presumably based on Amphilochius' *Life*, is found in John Malalas' *Chronicle*, book 13.25 (ed. Dindorf, 333–4; Eng. trans. Jeffreys, 181–2), but again there is no mention of an icon: it is a dream.

[135]These passages are not from the *Dialogue on the Life of John Chrysostom*, composed after his death by his disciple, Palladius, but from a later *Life*, based on Palladius, by the seventh-century Bishop of Alexandria, George. The Proclus mentioned further on is John Chrysostom's disciple who later became Archbishop of Constantinople and had the saint's relics translated to Constantinople.

And a little further on:

He had a depiction of the same apostle Paul in an icon, in the place where he used to rest for a little while because of his bodily infirmity; for he was given to many vigils beyond nature. And when he had finished his epistles, he would gaze at it and attend to him as if he were alive and bless him, and bring the whole of his thoughts to him, imagining that he was speaking with him in his contemplation.

And after other words:

As when Proclus ceased speaking, he gazed at the image of the apostle and beheld his character to be like the one who had appeared to him [i.e., John]. Making a reverence[136] to John, he said, pointing with his finger to the icon, "Forgive me, Father, the one I saw speaking to you is like this; indeed, I assume that it is the very same."

62 (II.58): In the *Life of Saint Eupraxia* it is read that there appeared to her the figure of the Lord in the midst of the flock he guarded.[137]

63 (II.59): In the *Life of St Mary of Egypt* it is written that she prayed to an icon of Our Lady and besought her to become her guarantor and thus gained entrance to the church.[138]

64 (II.67): From the *Spiritual Meadow* of our holy father, Sophronius, Archbishop of Jerusalem:[139]

Abba Theodore the Æliote said that there was on the Mount of Olives a certain recluse, a great fighter; and the demon of fornication waged battle against him. One day, therefore, as he laid into him vehemently, the elder began to complain and said to the demon,

[136]Literally: *metanoia.*

[137]See *Images*, III.136, where this *Life* is quoted.

[138]See *Images*, III.135, where a passage from the *Life of Mary of Egypt* is cited.

[139]John Moschus, *Spiritual Meadow* 45 (PG 87.2900B-D; trans. Wortley, 35–6). The *Spiritual Meadow*, telling of the journey John Moschus and Sophronius of Jerusalem to visit the monks in Palestine, Syria, Sinai and Egypt at the end of the sixth century, is in fact by John Moschus, though in Byzantine times it was commonly cited, as here, as being by the more famous Sophronius.

"When are you going to leave me alone? For the future withdraw from me; you are growing old together with me." The demon showed himself visibly and said, "Swear to me that you will tell no one what I am going to say to you, and I shall fight against you no more." And the elder swore to him, "By the One who dwells in the highest, I shall not tell anyone what you say to me." Then the demon said to him, "Do not venerate this icon, and I will no longer wage battle against you." The icon had a depiction of our Lady, Holy Mary, the Mother of God, holding our Lord Jesus Christ. The recluse said to the demon, "Go away, I shall think about it." On the next day, therefore, it was revealed to Abba Theodore the Æliote who was then dwelling in the Laura of Pharan, and he went and was told everything. The elder said to the recluse, "Truly, you were mocked when you swore, but you did well to speak out. It would be better for you to leave no brothel in this town unentered than to refuse to venerate our Lord and God Jesus Christ together with his own mother." He then strengthened and confirmed him with many words, and then left to go to his own place. The demon therefore appeared again to the recluse and said to him, "What is this, you wicked old monk?[140] Did you not swear to me that you would tell no one? How then have you spoken out everything to one who came to you? I tell you, wicked old man, that you will be condemned as a perjurer on the day of judgment." The recluse answered him and said, "What I swore, I swore, and that I perjured myself, I know. But I swore falsely to my Lord and Maker; I will not listen to you."

65 (II.68): *Comment*: You see, that he spoke of veneration of the image of the one depicted, and how wicked it is not to venerate this, and how the demon would have preferred [such veneration] to fornication.

[140]The demon calls the recluse *kakogēros*, a derisory variant of *kalogēros*, "venerable," term of address to a monk (cf. the modern Greek *kalogeros*).

66 (II.69): Since many priests and emperors have been endowed with wisdom that comes to Christians from above, from God, and have been distinguished for their piety, their doctrine and their lives, and many synods of holy and divinely inspired fathers have taken place, why does no one attempt to explain these things? We shall not suffer a new faith to be taught. "For a law has come out from Sion," the Holy Spirit declares in prophecy, "and the word of the Lord from Jerusalem."[141] We shall not suffer different things to be thought at different times, changing with the seasons, and the faith to become a matter of ridicule and jest to outsiders. We shall not suffer the custom of the fathers to be subject to an imperial constitution that seeks to overthrow it. For it is not for pious emperors to overthrow ecclesiastical laws. For this is not the way of the fathers; for it is piratical for these things to be imposed by force, and they shall not prevail. Witness to this is the second synod that took place at Ephesus, which came to be called the "Robber Synod," imposed by the imperial hand, when the blessed Flavian was done to death.[142] These things are matters for synods, not emperors, as the Lord said, "Where two or three are gathered together in my name, there I am in the midst of them." It was not to emperors that Christ gave the authority to bind and loose, but to apostles and to those who succeeded them as shepherds and teachers. "And if an angel," says Paul the Apostle, "should proclaim another Gospel to you than that you have received":[143] and we keep silence about what follows, sparing them and hoping for their conversion. But if we see their madness continues without conversion, then we shall bring in what remains; but may this not be necessary!

[141]Isa 2:3.

[142]John Damascene refers to the synod of Ephesus held in 449, which upheld Eutyches against Flavian, patriarch of Constantinople. Flavian was so ill-treated that he died of his injuries. Pope Leo called this synod a *latrocinium* (act of robbery: *ep.* 95 to Pulcheria).

[143]Cf. Gal 1:8.

67 (II.70): If anyone enters a house, in which a painter has painted on the walls in colors the story of Moses and Aaron, then perhaps he will ask about those who led them through the sea as on dry land: "Who are these?" What will you reply, when asked? Surely: "The Children of Israel"? "Who is this striking the sea with his rod?" Surely: "Moses"? So that, if anyone depicts Christ crucified, and is asked, "Who is this?," he will say, "Christ God, who became flesh for our sake." Yes, Master, I venerate and embrace with ardent longing everything that is yours: your divinity, your power, your goodness, your mercy towards me, your descending to our condition, your incarnation, your flesh. And just as I am afraid of touching red-hot iron, not because of the nature of iron, but because of the fire that is united with it, so I venerate your flesh, not because of the nature of flesh, but because of the divinity hypostatically united to it. We venerate your sufferings. Who sees death venerated, or sufferings treated with reverence? But truly we venerate the bodily death of my God and the saving sufferings, we venerate your image; all that is yours we venerate, your servants, your friends, and above all the Mother who gave birth to you.

68 (II.71): Therefore I entreat the people of God, the holy nation,[144] to cling to the traditions of the Church. For just as the removal of one of the stones of a building will quickly bring ruin to that building, so will the removal, ever so little, of what has been handed down. Let us be firm, unflinching, unmoved, established upon the secure rock, which is Christ, to whom is due glory, honor and veneration, with the Father and the Spirit, now and for ever and to the unbounded ages of ages. Amen.

[144] 1 Pet 2:9, quoting Exod 19:6, which John probably applies not simply to the Church, but to the people of the Byzantine (or Roman) Empire.

The Second Discourse of the humble monk, John the Damascene, to those who speak against images

1 Grant forgiveness to one who asks, my masters, and receive a word of assurance from me, the least and useless slave of the Church of God. For, as God is my witness, it is not on account of glory or ostentation that I am urged to speak but out of zeal for the truth. For I possess this alone as my hope of salvation, and with it I hope to meet the Lord Christ and I pray that I may offer this to him in expiation for the monstrous ways in which I have erred. For he who had received from his master five talents approached, having gained another five, and he who received two came with an equal number, two. But the wicked slave, who had received one talent and buried it, approached with one talent without even interest and heard himself condemned to outer darkness. Fearing, therefore, lest I suffer the same fate, I set before you, as discerning assayers, the talent of eloquence that He gave me, so that when my Lord comes, he may find that it has multiplied and borne fruit in the form of souls, and finding me a faithful slave he may cause me to enter into his sweetest joy, for which I have longed. But give me an ear of hearing and lay out the tables of your hearts to receive my discourse and judge for its own sake the power of what I say, in this second discourse on images that I have put together. Some of the children of the Church have enjoined

me to do this because the first was not completely clear to everyone. But make allowances for me in this, as I seek to be obedient.

2 (cf. III.1) It is the custom of the wicked and primordially evil serpent, I mean the devil, to fight in many ways against human kind, formed in the image of God, and through his opposition to bring about his death. For right at the beginning, he sowed in him the seeds of hope and desire for deification and through it brought him down to the death of animals, and not only that but also enticed him many times by shameful and irrational pleasures. How utterly opposed is deification to irrational desire! He led him once to godlessness, as David the divine ancestor said, "the foolish one said in his heart, There is no God";[1] another time to polytheism; yet another time he persuaded him not to venerate the one who is by nature God, at another to venerate demons, or else heaven and earth, the sun and moon and stars, and the rest of creation, right down to wild beasts and reptiles. For it is just as bad not to offer the honor due to those who are worthy, as it is to offer inappropriate glory to the worthless. Again he teaches some to say that evil is without beginning together with God, others he utterly deceives to confess that God, who is by nature good, is the cause of evil. And he leads those astray who stupidly say that there is one nature and one person of the Divinity, and corrupts others who unlawfully worship three natures and three persons. And he instructs those who imagine that there is one person and one nature of our Lord Jesus Christ, who is one of the holy Trinity, as well as those who think he has two persons and two natures.

3 The truth, pursuing a middle way,[2] denies all these absurdities, and teaches the confession of one God, one nature in three persons,

[1]Ps 13:1; 52:2.

[2]John is fond of presenting Orthodoxy as a "middle way": cf. *On the Orthodox Faith,* 7; *Against the Jacobites,* 3; *On the Faith against the Nestorians,* 1. The theme is also found in the Cappadocian Fathers (cf. Gregory of Nyssa, *Great Catechetical Oration,* 3).

Father, Son and Holy Spirit. It says that evil is not being, but an accident, a certain idea and reason and deed contrary to the law of God, having its existence in thinking and reasoning and doing, and vanishing as soon as these cease. It is proclaims that one of the holy Trinity, Christ, is two natures and one person.

4 (cf. III.1) But the enemy of truth, who fights against the salvation of human kind, who once led astray not only the nations to make images of demons and wicked human beings and birds and wild beasts and reptiles and venerate them as God, but also many times the sons of Israel themselves, now that the Church of Christ has peace, is eager to trouble it by mixing evil with divine words through unjust lips and a crafty tongue, and trying to cover up its dark and shapeless form and shake the hearts of the unstable from the true customs, handed down from the Fathers. For certain have risen up, saying that it is not necessary[3] to make images of the saving miracles and sufferings of Christ and the brave deeds of the saints against the devil, and set them up to be gazed at, so that we might glorify God and be filled with wonder and zeal. Does anyone, who has divine knowledge and spiritual understanding, not recognize that this is a ruse of the devil? For he does not wish his defeat and shame to be spread abroad, nor the glory of God and his saints to be recorded.

5 (cf. III.2) For if we were to make an image of the invisible God, we would really sin; for it is impossible to depict one who is incorporeal and formless, invisible and uncircumscribable. And again: if we were to make images of human beings and regard them and venerate them as gods, we would be truly sacrilegious. But we do none of these things. For if we make an image of God who in his ineffable goodness became incarnate and was seen upon earth in the flesh, and lived among humans, and assumed the nature and density and

[3]Or: it is forbidden (the Greek could mean either).

form and color of flesh, we do not go astray. For we long to see his form; as the divine apostle says, "now we see puzzling reflections in a mirror."[4] For the image is a mirror and a puzzle, suitable to the density of our body. For the intellect, greatly tired, is not able to pass beyond the bodily, as the divine Gregory says.[5]

6 (III.3) Away with you, envious devil, for you are envious of us, when we see the likeness of our Master and are sanctified by him, when we see all that he endured for our salvation and wonder at his descent to our condition, when we see his miracles and recognize and glorify the power of his divinity. You envy the saints the honor given them by God. You do not want us to see their glory recorded and become zealous for their courage and faith. You cannot bear the bodily and spiritual benefit that comes from faith in them. We are not persuaded by you, envious demon, hater of human kind. Hear, peoples, tribes, tongues, men, women, children, old men and women, youths and infants, the holy nation of Christians: if anyone proclaims to you anything other than the Catholic Church has received from the holy Apostles and Fathers and synods and pre-served up to now, do not listen to him nor accept the counsel of the serpent, as Eve accepted it and reaped death. If an angel, or an emperor, were to proclaim to you other than you have received, shut your ears. For the moment I hesitate to say, as the divine apostle said, "Let him be anathema!"[6] for he may receive correction.

7 (III.4) But those, who do not search out the meaning of Scrip-ture, say that God said through Moses the lawgiver, "Do not make any likeness, whether of things in heaven or of things on the earth,"[7] and through David the prophet, "Let those who venerate carved

[4]1 Cor 13:12.
[5]Gregory Nazianzen, *Hom.* 28.13 (ed. Gallay, 128). Cf. *Images*, I.11, III.2, 21.
[6]Or: Let him be accursed! Gal 1:8–9.
[7]Cf. Exod 20:4; Deut 5:8.

[images] be put to shame, those who boast in their idols,"[8] and many other similar passages. For whatever they allege from the divine scriptures and the holy Fathers, it is all with the same intention.

What therefore do we say to these? What else, save what was said by the Lord to the Jews: "Search the scriptures"? It is good to search the scriptures. But take care to do it with discretion. It is impossible, beloved ones, for God to lie. For there is one God, one lawgiver[9] of the Old and New Testaments, who of old spoke in many and various ways to the fathers by the prophets and in the last times by his Only-begotten Son. Pay careful attention. It is not my word. The Holy Spirit through Paul the holy apostle declares, "in many and various ways God spoke of old to the fathers by the prophets."[10] See that God spoke in many and various ways. For just as the physician knows not always to give the same remedy to all, but supplies to each one what is suitable, determining a medicine appropriate to place and disease and time, that is, season and condition and time of life, and therefore offers one thing to a baby, another to someone full grown, according to the time of life, one thing to the sickly, another to the healthy, and to each of those who are sickly not the same, but something in accordance with their condition and disease, and one thing in summer, another in winter, or autumn or spring, and in each place and in accordance with what is suitable to the place. So the best physician of souls prohibits from making images those who are still infants and ill with a diseased inclination to idolatry, apt to regard idols as gods and venerate them as gods and reject the veneration of God and offer his glory to the creation. For it is impossible to make an image of God who is incorporeal, invisible, immaterial and with neither shape nor circumscription nor apprehension; how can what

[8]Ps 96:7.

[9]The manuscripts give different readings here; most give the usual word (*nomothetēs*), but some (preferred by Kotter) give a different word (*nomodotēs*), one that stresses the element of giving, thus making a distinction between God and Moses, who has also been called lawgiver earlier on in this section.

[10]Heb 1:1–2.

cannot be seen be depicted? "No one has ever seen God; the Only-begotten Son, who is in the bosom of the Father, he has declared him,"[11] and "No one shall see my face, and live,"[12] said God.

8 (III.5) And that they did venerate idols as gods, listen to what Scripture says in the Exodus of the sons of Israel, when Moses went up on to Mount Sinai and was there for some time, waiting to receive the law from God, when the senseless people rose up against the servant of God, Aaron, saying, "Make us gods to go before us; as for this man, Moses, we do not know what has become of him."[13] Then, when they had taken off the ornaments of the women and melted them down, they ate and drank and became drunk with wine and illusion and, in their folly, began to play, saying, "These are your gods, Israel."[14] You see that they had idols as gods. For they did not make an idol of Zeus or one of the other gods, but, as it happened, they gave the gold to make an idol, whatever it might be, and there was set up an ox-headed image. So they took these images in cast metal for gods and venerated them as gods, images that were the dwelling-places of demons. And the divine apostle also says that they venerated the creation instead of the Creator: "they exchanged the glory of the incorruptible God for a corruptible human likeness and the likeness of birds and quadrupeds and reptiles and they worshiped the creation instead of the Creator."[15] For this reason, God prohibited any likeness, as Moses says in Deuteronomy, "And the Lord spoke to you from the midst of the fire; you heard the sound of his words and you did not see any likeness, but only a voice," and a little later, "take good heed to your soul, for you did not see a likeness on the day, when the Lord spoke to you on Horeb in the mountain in the midst of the fire. Beware lest you act lawlessly and make for yourselves a carved

[11]Jn 1:18.
[12]Exod 33:20.
[13]Cf. Exod 32:1.
[14]Exod 32:4.
[15]Cf. Rom 1:23, 25.

likeness, any image, a likeness of a male or a female, a likeness of any beast that is upon the earth, a likeness of any winged bird" and so on, and after a little, "Beware lest you look up in the sky and see the sun and the moon and the stars and all the order of heaven, and being led astray venerate them and worship them."[16] You see that the single purpose of this is that one should not worship, or offer the veneration of worship, to creation instead of the Creator, but only to the One who fashioned all. Therefore everywhere it concerns worship by veneration. Again it says, "There shall be for you no other gods beside me, you shall not make for yourself a carved [image] nor any likeness,"[17] and again, "you shall not make for yourself any gods of cast metal."[18] You see how it was on account of idolatry that he prohibited the painting of images, and that it is impossible to depict God who is incommensurable and uncircumscribable and invisible. "For," it says, "you have not seen his form,"[19] just as also Paul, standing in the midst of the Areopagus, said, "Being then God's offspring, we ought not to think that the divine is like gold, or silver, or stone, a representation of human art and imagination."[20]

9 (III.9) And that these things are so, listen: "You shall not make for yourself any carved [image] or any likeness."[21] But these are the things that God commanded "they should make," it says: "the veil of the tabernacle of witness from aquamarine and porphyry and spun scarlet and twisted flax, woven work of the cherubim,"[22] and "they made the mercy seat above the ark and the two cherubim out of pure gold."[23] What are you doing, Moses? You say, "You shall not make for

[16]Deut 4:12, 15–17, 19.
[17]Exod 20:4, and cf. Deut 5:7.
[18]Exod 34:17.
[19]Jn 5:37.
[20]Acts 17:29.
[21]Deut 5:8.
[22]Exod 37:3 LXX; John's text is slightly different from the LXX, which reads "a work with cherubim woven in," which is closer to the Hebrew: cf., in English Bibles, Exod 36:8.
[23]Exod 38:5–6 LXX; cf. in English Bibles, Exod 37:6–7.

yourself a carved [image] or any likeness," and you fashion the veil, "a woven work of cherubim" and "two cherubim out of pure gold"? But listen, what the servant of God, Moses, answers you in his works. O blind and foolish, understand the power of what is said "and take good heed to your souls."[24] I said, "that you saw no likeness on the day in which the Lord spoke to you at Horeb on the mountain in the midst of the fire, lest you act lawlessly and make for yourselves a carved likeness, or any image,"[25] and "you shall not make for yourselves gods of cast metal."[26] I did not say, You shall not make an image of the cherubim that stand as slaves beside the mercy seat, but "you shall not make for yourself gods of cast metal," and "you shall not make any likeness" as of God, nor shall you worship "the creation instead of the Creator." Therefore I did not make a likeness of God, nor of anything else as God, nor "did I worship the creation instead of the Creator." But you behave like that.

10 (cf. III.9) You know how the purpose of Scripture is made clear to those who search intelligently. For it is necessary to know, beloved, that in every action truth and falsehood are to be sought out and the purpose of the one who acts, whether it is good or evil. For in the Gospel, God and angel and human being and heaven and earth and water and fire and air and the sun and the moon and stars and light and darkness and Satan and demons and serpents and scorpions and death and Hades and virtues and vices and everything that is good and bad are written about. But since everything said about them is true and the purpose is the glory of God and of the saints glorified by him, and our salvation and the overthrow and disgrace of the devil and his demons, all these we venerate and embrace and kiss with eyes and lips and cleave to in our hearts, likewise the whole of the Old and New Testaments and the words of the holy and select Fathers, but the shameful and filthy and unclean writing of the accursed Manichees

[24]Deut 4:15.
[25]Deut 4:15–16.
[26]Exod 34:17.

and Greeks and of the rest of the heresies we spit out and reject as containing lies and emptiness, devised for the glory of the devil and his demons and their delight, even though they contain the name of God. So also in the matter of images, it is necessary to search out the truth and the purpose of those who make them, and, if they turn out to be true and upright, promoting the glory of God and his saints, and inspiring virtue and driving away vice, and leading to the salvation of souls, then to accept and honor them as images and copies and likenesses and books for the illiterate, and to venerate and kiss them with eyes and lips, and cleave to them in our hearts, as a likeness of God incarnate, or of his Mother, or of saints who shared in the sufferings and the glory of Christ and were conquerors who overthrew the devil and the demons and their error, but if anyone dare to make an image of the immaterial and incorporeal and invisible and formless and colorless divinity, we reject them as false. And anything to the glory and veneration and honor of the devil and the demons, we spit on and destroy by fire. And if anyone makes a god of an image of humans or birds or reptiles or any other creature, we anathematize him. For just as the holy Fathers destroyed the sacred places and temples of the demons and in their place raised up temples in the name of the saints, and we reverence them, so they destroyed the images of the demons and instead of them put up images of Christ and the Mother of God and the saints. And of old, Israel neither set up temples in the name of human beings nor celebrated the memorial of any human—for human nature was still under the curse and death was condemnation, therefore they were enjoined that even the body of someone dead was to be reckoned unclean, and also anyone who touched it—but now, since the divinity has been united to our nature, as a kind of lifegiving and saving medicine, our nature has been glorified and its very elements changed[27] into incorruption.

[27]John uses a rather rare word here, *metastoicheioō*, literally "transelement," which has a variety of uses in the Fathers: to describe the resurrection body (Gregory of Nyssa), the transformed state of Christ's humanity (esp. Cyril of Alexandria) and the change in the eucharistic elements (Gregory of Nyssa).

Therefore the death of the saints is celebrated and temples raised for them and images engraved.

11 (cf. III.10) Let everyone know, therefore, that anyone who attempts to destroy an image brought into being out of divine longing and zeal for the glory and memorial of Christ, or of his Mother the holy *Theotokos*,[28] or of one of the saints, or for the disgrace of the devil and the defeat of him and his demons, and will not venerate or honor or greet it as a precious image and not as god, is an enemy of Christ and the holy Mother of God and the saints and a vindicator of the devil and his demons, and shows by his deed his sorrow that God and his saints are honored and glorified, and the devil put to shame. For the image is a triumph and manifestation and inscribed tablet in memory of the victory of the bravest and most eminent and of the shame of those worsted and overthrown.

12[29] It is not for emperors to legislate for the Church. For look what the divine apostle says: "And God has appointed in the Church first apostles, secondly prophets, thirdly pastors and teachers, for the equipment of the saints,"[30]—he did not say emperors—and again "Obey your leaders and submit to them; for they are keeping watch over your souls, as men who will have to give account."[31] And again, "Remember your leaders, those who spoke to you the word; consider the outcome of their lives, and be zealous for their faith."[32] Emperors did not speak to us the word, but apostles and prophets, pastors and teachers. When God commanded David to build him a house, he said to him that "it is not you who are to build me a house, since you are a man of blood."[33] "Pay all of them their dues," the apostle

[28]I have normally translated *Theotokos* as "Mother of God," but here, in apposition to "Mother," it would sound odd.

[29]Cf. this section with *Images*, I.66.

[30]Cf. 1 Cor 12:28, Eph 4:11–12.

[31]Heb 13:17.

[32]Cf. Heb 13:7.

[33]Cf. 1 Par 28:3.

Paul cries out, "honor to whom honor is due, fear to whom fear is due, taxes to whom taxes are due, revenue to whom revenue is due."[34] Political good order is the concern of emperors, the ecclesiastical constitution that of pastors and teachers. This is a piratical attack, brothers. Saul tore the garment of Samuel, and what happened? God tore from him his kingdom and gave it to David the most meek. Jezebel persecuted Elias, and the dogs bathed in her blood. Herod did away with John, and he gave up his life eaten of worms. And now the blessed Germanus,[35] radiant in his life and his words, is flogged and sent into exile, and many other bishops and fathers, whose names we do not know. Is not this piracy? The Lord, when the scribes and Pharisees approached him to tempt him that they might ensnare him in an argument, and asked him, if "it is lawful to pay taxes to Cæsar," replied to them, "Fetch me a nomisma." And to those who brought it, he said, "Whose is the image?" and when they replied, "Cæsar's," he said, "Render therefore to Cæsar the things that are Cæsar's, and to God the things that are God's." We submit to you, O Emperor, in the matters of this life, taxes, revenues, commercial dues, in which our concerns are entrusted to you. For the ecclesiastical constitution we have pastors who speak to us the word and represent the ecclesiastical ordinance. We do not remove the ancient boundaries, set in place by our fathers,[36] but we hold fast to the traditions, as we have received them. For if we begin to remove even a tiny part of the structure of the Church, in a short time the whole edifice will be destroyed.

13 You abuse matter and call it worthless. So do the Manichees, but the divine Scripture proclaims that it is good. For it says, "And God saw everything that he had made, and behold it was exceedingly

[34]Cf. Rom 13:7.

[35]Germanus I, Patriarch of Constantinople 715–30, deposed for his refusal to accept the imperial policy of iconoclasm.

[36]A close allusion to Prov 22:28, one of John's favorite texts, quoted in *Images*, I.22 and at the end of the first chapter of *On the Orthodox Faith*.

good."[37] I therefore confess that matter is something made by God and that it is good, you, however, if you say it is evil, either do not confess that it is from God, or make God the cause of evils. See, therefore, what the divine Scripture says about matter, which you call worthless: "And Moses spoke to all the congregation of the sons of Israel, saying, This is the word which the Lord has commanded, saying, Take from among you an offering to the Lord. Whoever has a generous heart, let him offer the first-fruits to the Lord, gold, silver, bronze, aquamarine, porphyry, scarlet twill and twisted flax and goats' hair and rams' skin dyed red and skins dyed aquamarine and acacia wood and oil for anointing and spices for incense and carnelians and precious stones for engraving and for the shoulder-piece and the robe. And let every one wise in heart among you come and work everything, that the Lord has commanded, the tabernacle."[38]

14 (cf. I.16) Behold, therefore, that matter is honored, which according to you is worthless. For what could be cheaper that goats' hair and colors? Or are scarlet and porphyry and aquamarine not colors? Behold both the works of human hands and the likeness of the cherubim; and this whole tabernacle was an image. "For look," said the Lord to Moses, "that you make everything according to the type that you received on the mount."[39] And so it was venerated from all round by the whole of Israel. What were the cherubim? Were they not right in front of the people? And the ark and the lampstand and the table and the golden jar and the rod, looking towards which the people bowed down in veneration? I do not venerate matter, I venerate the fashioner of matter, who become matter for my sake, and in matter made his abode, and through matter worked my salvation. "For the Word became flesh and dwelt among us."[40] It is clear to all, that flesh is matter and is a creature. I reverence therefore

[37]Gen 1:31.
[38]Exod 35:4–10.
[39]Cf. Exod 25:40.
[40]Jn 1:14.

matter and I hold in respect and venerate that through which my salvation has come about, I reverence it not as God, but as filled with divine energy and grace. Is not the thrice-precious and thrice-blessed wood of the cross matter? Is not the holy and august mountain, the place of the skull, matter? Is not the life-giving and life-bearing rock, the holy tomb, the source of the resurrection, matter? Is not the ink and the parchment[41] of the Gospels matter? Is not the life-bearing table, which offers to us the bread of life, matter? Is not the gold and the silver matter, out of which crosses and holy tablets are fashioned and also bowls? And, before all these things, is not the body and blood of my Lord matter? Either do away with reverence and veneration for all these or submit to the tradition of the Church and allow the veneration of images of God and friends of God, sanctified by name and therefore overshadowed by the grace of the divine Spirit. If because of the law you prohibit images, watch that you keep the sabbath and are circumcised—for the law commands all these unyieldingly—and keep the whole law, and do not celebrate the Lord's Pascha outside Jerusalem—but know that, if you keep the law, Christ is no use to you—watch that you marry the wife of your brother and raise up children for your brother, and do not sing the Lord's song in a strange land. But enough! For "you who would be justified by the law have fallen from grace."[42]

15 (cf. I.21) We represent Christ the King and Lord without divesting him of his army. For the saints are the army of the Lord. Let the earthly emperor divest himself of his own army, before he deprives his own King and Lord. Let him put aside the purple robe and the diadem, and then let him do away with those who fight most bravely against the tyrant and triumph over the passions. If they are heirs of God and co-heirs with Christ and partakers of the divine glory and kingdom, how shall not the friends of Christ be also fellow

[41]Literally: skins.
[42]Gal 5:4.

partakers on earth of his glory? "I do not call you slaves," says God, "you are my friends."[43] Should we then deprive them of the honor given them by the Church? O rash hand! O audacious opinion, rebelling against God and refusing to perform his commands! You do not venerate an image, nor do you venerate the Son of God, who is the living "image of the invisible God"[44] and his undeviating likeness. The temple that Solomon built was dedicated with the blood of animals and adorned with images of animals, of lions and bulls and phœnixes[45] and pomegranates. Now the Church is dedicated by the blood of Christ and his saints and adorned with an image of Christ and his saints. Either do away with any veneration of matter or do not innovate, "neither remove the ancient boundaries, set in place by your fathers,"[46] I do not mean those before the incarnate presence of Christ our God, but those after his advent. For God complained of the traditions in the Old [Testament], when he said, "I have given you ordinances that were not good"[47] in accordance with the hardness of your hearts. So "when there was a change in the priesthood, of necessity there was a change in the law as well."[48]

16 (cf. I.23). The eye-witnesses and ministers of the word not only handed down the law of the Church in writings, but also in certain unwritten traditions. For whence do we know the holy place of the skull? Whence the memorial of life? Does not a child learn it from his father without anything being written down?[49] It is written that the Lord was crucified in the place of the skull and buried in a tomb, that Joseph had had hewn in a rock; but that these are the places now

[43]Cf. Jn 15:14–15.

[44]Col 1:15.

[45]Or: palm trees. Cf. Images, III, n. 221.

[46]Prov 22:28, one of John's favorite texts, quoted in Images, I.22 and at the end of the first chapter of On the Orthodox Faith, and alluded to above (Images, II.12).

[47]Ezek 20:25.

[48]Cf. Heb 7:12.

[49]In modifying the parallel passage in Images, I, John has left the participle in the plural, while making the subject singular.

venerated we know[50] from unwritten tradition, and there are many other examples like this. What is the origin of threefold baptism, that is with three immersions? Whence praying facing the East? Whence veneration of the cross?[51] Are they not from unwritten tradition? Therefore the divine apostle says, "So then, brethren, stand firm and hold to the traditions which you were taught by us, either by word of mouth or by our letter."[52] Since many things have been handed down in unwritten form in the Church and preserved up to now, why do you split hairs over the images? Manichees composed the Gospel according to Thomas; are you now going to write the Gospel according to Leo?[53] I do not accept an emperor who tyrannically snatches at the priesthood. Have emperors received the authority to bind and to loose? I know that Valens was called a Christian emperor and persecuted the Orthodox faith, as well as Zeno and Anastasius, Heraclius and Constantine who [died] in Sicily, and Bardanes Philippicus.[54] I am not persuaded that the church should be constituted by imperial canons, but rather by patristic traditions, both written and unwritten. For just as the Gospel was proclaimed in all

[50]John has substituted for *ismen,* used in *Images,* I.23, the less correct form of the verb *oida.*

[51]John has altered his list of examples from *Images,* I.23. The examples of unwritten tradition, as remarked before, are taken from Basil's *On the Holy Spirit,* 27.66 (the beginning of which is quoted in I.23). Basil does not speak, however, of veneration of the cross, simply of making the sign of the cross.

[52]2 Thess 2:15.

[53]The Gospel of Thomas is one of the apocryphal gospels, included by the Manichees among their scriptures, though not actually written by them (as John alleges); the gospel is older than that (it is among the gnostic writings discovered at Nag Hammadi). Leo is the Emperor Leo III, who introduced iconoclasm as imperial policy in 726.

[54]Valens, who supported the Homœans, was emperor 364–78; Zeno, who promulgated the *Henotikon* and thus sought to undermine the authority of Chalcedon, was emperor 474–76, 476–91; Anastasius, who succeeded him and continued his policy, was emperor 491–518; Heraclius, who promoted monenergism and monothelitism, was emperor 610–41; Constantine (Constans II), his grandson, who continued to support monothelitism, was emperor 641–68; Bardanes Philippicus, who attempted to restore monothelitism during his brief reign, was emperor 711–13.

the world in written form, so in all the world it has been handed down in unwritten form that Christ the incarnate God should be depicted, and the saints, just as the cross is venerated and we stand to pray, facing the East.

17 (cf. I.24) The practices that you bring up do not make our veneration of images loathsome, but those of the idolatrous Greeks.[55] It is not necessary, on account of pagan abuse, to abolish the pious practice of the Church. Enchanters and sorcerers practice exorcism, the Church exorcizes catechumens; but they call upon demons, while the Church calls upon God against demons. Greeks sacrifice to demons, but Israel also offers blood and burnt sacrifices to God; while the Church sacrifices to God, offering him a bloodless sacrifice. Greeks dedicate images to demons, but Israel also makes gods of images, for they said, "These are your gods, Israel, that led you up out of Egypt."[56] We dedicate images to the true God incarnate and the servants and friends of God and drive away the hosts of the demons.

18 (cf. I.25) If you say that the blessed Epiphanius clearly prohibited our images, then know that the work in question is forged, being the work of another and using the name of the divine Epiphanius, which often happens. For a father does not fight against his fellow-fathers, for they are all partakers of the one Holy Spirit. Further, there is the witness of his own church, decorated with images until the wild and savage Leo devoured them and troubled the flock of Christ, trying to make the people of God drink polluted waters.[57]

[55]For John, as for any Christian Byzantine, "Greek" (*hellēn*) meant "pagan." The word translated "idolatrous" literally means "god-making."

[56]Exod 32:4.

[57]John had evidently heard of iconoclast activity in Cyprus in obedience to the imperial decree. His information was no doubt accurate, though we have no confirmation of it.

19 If I venerate and reverence the cross and the lance and the reed and the sponge, with which the deicide Jews insulted my Lord and killed him, as the cause of my salvation, shall I not venerate the images of the sufferings of Christ, fashioned with a good purpose by those who believe, for his glory and in his memory? If I venerate the image of the cross, made of whatever wood, shall I not venerate the image of the crucified one, showing the saving cross? That I do not venerate matter is plain. For once the pattern of the cross is destroyed, and (say) it is made of wood, then I will consign the wood to the fire, and so with images.

20 That this invention of images and their veneration is nothing new, but an ancient tradition of the Church, accept from a host of scriptural and patristic sayings. In the sacred Gospel according to Matthew, the Lord said these things to his disciples, blessing also with them all who would take them as their model, and follow their footsteps: "Blessed are your eyes, because they see, and your ears, because they hear. Amen I say to you, that many prophets and just people longed to see what you see, and did not see, and hear what you hear, and did not hear."[58] We also therefore long to see what it is possible to see, "for we see puzzling reflections in a mirror,"[59] and we are blessed in the image. God Himself first made an image and showed us images, for he made human kind in accordance with the image of God.[60] And Abraham and Moses and Isaias and all the prophets saw images of God and not the very being of God. The [burning] bush is an image of the Divine Mother, and God said to Moses when he was about to approach it, "Loose the sandals from your feet, for the ground, on which you stand, is holy ground."[61] If,

[58]Matt 13:16–17.

[59]1 Cor 13:12.

[60]John does not mention human creation in the image of God as a justification for making images in *Images* I, although it is the first reason he gives in the relevant chapter of *On the Orthodox Faith* (89), and he adds it to his list of the different theological meanings of image in *Images*, III.20.

[61]Exod 3:5.

therefore, the ground on which the image of the Mother of God was
seen by Moses is holy ground, how much more is the image itself?
For not only holy, but, dare I say it, also the holy of holies. The Lord
was asked by the Pharisees, "Why then did Moses command one to
give a certificate of divorce, and to put her away?" And he answered,
"For your hardness of heart Moses allowed you to divorce your
wives, but from the beginning it was not so."[62] And I say to you, that
Moses, on account of the hardness of heart of the sons of Israel,
ordered them not to make images, for he knew their tendency to slip
into idolatry. But now it is not so; we stand securely on the rock of
faith enriched by the light of the knowledge of God.

21 Hear what the Lord says: "You blind fools! Whoever swears by
the temple, swears by it and by him who dwells in it; and whoever
swears by heaven, swears by the throne of God and by him who sits
upon it."[63] And whoever swears by an image swears by the image and
the one depicted on it.

22 It has been sufficiently demonstrated that the tabernacle and
the veil and the ark and the table and everything in the tabernacle
were images and types and works made by human hands, which
were venerated by all Israel, and further that cherubim were fash-
ioned as carving by the command of God. For God said to Moses,
"See that you make everything according to the pattern which was
shown you on the mountain."[64] Hear also the apostle Paul bearing
witness that, at God's command, Israel venerated things made by
hand and images: "Now if he were on earth, he would not be a priest
at all, since there are priests who offer gifts according to the law. They
serve a copy and shadow of the heavenly sanctuary; for when Moses
was about to erect the tent, he was instructed by God, saying, 'See

[62]Matt 19:7–8.
[63]Matt 23:17, 21–2.
[64]Exod 25:40.

that you make everything according to the pattern which was shown you on the mountain.' But as it is, Christ has obtained a ministry which is as much more excellent than the old as the covenant he mediates is better, since it is enacted on better promises. For if that first covenant had been faultless, there would have been no occasion for a second. For he finds fault with them when he says: 'The days will come, says the Lord, when I will establish a new covenant with the house of Israel and with the house of Judah; not like the covenant that I made with their fathers on the day when I took them by the hand to lead them out of the land of Egypt.'"[65] And a little later, "In speaking of a new [covenant] he treats the first as obsolete. And what is becoming obsolete and growing old is ready to vanish away. Now even the first covenant had regulations for worship and an earthly sanctuary. For a tabernacle was prepared, the outer one, in which were the lampstand and the table and the setting forth of the bread; it is called the sanctuary. Behind the second curtain stood a tabernacle called the Holy of Holies, having a golden altar of incense and the ark of the covenant covered on all sides with gold, which contained a golden jar holding the manna, and Aaron's rod that budded, and the tablets of the covenant; above it were the cherubim of glory overshadowing the mercy seat."[66] And again, "for Christ has entered, not into a sanctuary made with hands, a copy of the true one, but into heaven itself."[67] And after some other verses, "for the law, being a shadow of the good things to come, is not itself the image of the realities."[68]

23 See that the law and everything done in accordance with it, as well as our worship, are holy things made by hand that lead us through matter to the immaterial God, and that the law and everything done in accordance with it was a kind of shadow of the image

[65]Heb 8:4–9.
[66]Heb 8:13–9:5a.
[67]Heb 9:24.
[68]Heb 10:1.

to come, that is, of our worship, and that our worship is an image of the good things to come, the realities themselves, that is Jerusalem above, immaterial and not made by hand, as the same divine apostle says, "For here we have no abiding city, but we seek one that is to come,"[69] that is Jerusalem above, "whose builder and maker is God."[70] Everything in accordance with the law, and everything in accordance with our worship, happened for its sake. To Him be glory to the ages of ages.

There follows here the florilegium that formed the conclusion of the first Treatise (I.28–68), with the following passages inserted between chapters 63 and 64 of the first Treatise (between chapters 59 and 67 in the enumeration of the second Treatise).

60 (cf. III.105) From the homily of Chrysostom, that there is one lawgiver of the Old and the New [Covenants], and on the clothing of the priest:[71]

And I loved the picture in wax, full of piety; for I saw an angel in an icon striking the companies of the barbarians. I saw the tribes of the barbarians trampled upon and David speaking the truth: "Lord, in your city you have brought their image to nothing."[72]

61 The same, from his interpretation of the parable of the seed:[73]

If you insult the imperial clothing, do you not insult the one thus clothed? Do you not know that, if you insult the image of the Emperor, you carry your insult to the archetype of this dignity? Do

[69]Heb 13:14.

[70]Heb 11:10.

[71]Actually from a homily by Severian of Gabala: PG 56.407. Quoted at Nicæa II.

[72]Ps 72:20.

[73]The source of this passage is unknown. What it states, however, is something of which John Chrysostom himself was well aware. In 387, when he was priest at Antioch, a number of imperial statues were pulled down in a riot. The people of Antioch feared the direst consequences, and while Flavian the bishop (and Libanius, the pagan rhetor) appealed to the Emperor for clemency, John admonished and consoled the people of Antioch in a series of homilies, "On the Statues" (PG 49.15–222).

you not know that, if anyone pulls down an image of wood and bronze in the form of a man, he will not be judged as having dared to do this to lifeless matter, but as having wanted to insult the Emperor? The insult borne to the Emperor's image entails insult to the Emperor himself.

62 The same John Chrysostom, from his homily on Meletius, bishop of Antioch and martyr, and on the zeal of those gathered together, which begins: "Casting his eyes everywhere at this holy flock," and shortly after:[74]

And what he did was a teaching of piety; constantly we are constrained to recall his discourse and to have that saint in our souls, having his name as a refuge from every irrational passion and thought, and this happened so much that everywhere, in the street and in the marketplace and in the fields, on all sides there echoes this name. You experience such a longing, not only for his name but also for the figure of his body. Whatever, therefore, you do with his name, you also fashion with his image. For many depict that holy image on rings and drinking-cups and dishes and on bedroom walls and everywhere, so that they not only hear his holy discourse but also see everywhere the figure of his body, and thus have a double consolation for his departure from us.

63 The same, on Judas' treachery, and on Easter, and on the tradition of the mysteries, and on not being resentful:[75]

For, just as painters also outline and sketch lines on a drawing-tablet and add the truth of colors, so also does Christ.

64 Saint Ambrose, Bishop of Milan, from his epistle to all Italy:[76]

On the third night of the fast, my body being already subdued, I was not asleep, but in ecstasy someone was clearly revealed to me

[74]St John Chrysostom, *Panegyric on St Meletios* (PG 50.516). Quoted at Nicæa II.
[75]St John Chrysostom, *Homily* I *on the treachery of Judas* (PG 49.379).
[76]From a pseudonymous letter (Aubineau, 8, 11).

with a certain face, which was like that of the blessed Paul the Apostle, the same shape that appears in icons clearly indicating his form.

65 (cf. III.131) Maximus the Philosopher and Confessor from what happened to him between him and Theodosius the Bishop:[77]

And at this everyone rose with joy and tears and made a reverence,[78] and prayer took place, and each of them kissed the holy Gospels and the precious Cross and the icon our God and Savior Jesus Christ and of our Lady, the all-holy Mother of God, who bore him, placing their own hands as a confirmation of what had been spoken.

66 (cf. III.127) The most holy and most blessed Archbishop of Theoupolis[79] and Patriarch, Anastasius, on the Sabbath, to Symeon, bishop of Bostra:[80]

Just as in the absence of the Emperor his image is venerated in his stead, so in his presence it would be strange to neglect the archetype and venerate the image; but this does not mean that, because it is not venerated when the one for whose sake it is venerated is present, it must be dishonored.

And a little further on:

For just as he who abuses the image of the emperor suffers punishment as if he had dishonored the Emperor himself, even though the image is nothing other than wood and paints mixed and blended with wax, in the same way he who dishonors the figure of someone offers an insult to the one whose figure it is.

[77]From the *Disputation between St Maximos the Confessor and Theodosios the Bishop at Bizya* (PG 90.156; ed. Allen-Neil, 117, lines 462–67); cited at Nicæa II.

[78]*Metanoia.*

[79]That is, Antioch.

[80]Anastasios of Antioch, *Fragment on the Sabbath* (PG 89.1405). Quoted at Nicæa II.

Discourse by the same Saint John Damascene against those who attack the august and holy images

1 (cf. II.2, 4) It is the custom of the wicked and primordially evil serpent, I mean the devil, to fight in many ways against human kind, formed in the image of God, and through his opposition to bring about his death. For right at the beginning, he sowed in him the seeds of hope and desire for deification and through it brought him down to the death of animals, and not only that but also enticed him many times by shameful and irrational pleasures. How utterly opposed is deification to irrational desire! He led him once to god-lessness, as David the divine ancestor said, "the foolish one said in his heart, There is no God";[1] another time to polytheism; yet another time he persuaded him not to venerate the one who is by nature God, at another to venerate demons, or else heaven and earth, the sun and moon and stars, and the rest of creation, right down to wild beasts and reptiles. For it is just as bad not to offer the honor due to those who are worthy, as it is to offer inappropriate glory to the worthless. The truth, pursuing a middle way,[2] denies all these

[1]Ps 13:1; 52:2.

[2]John is fond of presenting Orthodoxy as a "middle way": cf. *On the Orthodox Faith*, 7; *Against the Jacobites*, 3; *On the Faith against the Nestorians*, 1. The theme is also found in the Cappadocian Fathers (cf. Gregory of Nyssa, *Great Catechetical Oration*, 3).

absurdities. But the enemy of truth, who fights against the salvation of human kind, who once led astray not only the nations to make images of demons and wicked human beings and birds and wild beasts and reptiles and venerate them as God, but also many times the sons of Israel themselves, now that the Church of Christ has peace, is eager to trouble it by mixing evil with divine words through unjust lips and a crafty tongue, and trying to cover up its dark and shapeless form and shake the hearts of the unstable from the true customs, handed down from the Fathers.

2 (cf. II.4–5) For certain have risen up, saying that it is not necessary[3] to make images of the saving miracles and sufferings of Christ and the brave deeds of the saints against the devil, and set them up to be gazed at, so that we might glorify God and be filled with wonder and zeal. Does anyone who has divine knowledge and spiritual understanding not recognize that this is a ruse of the devil? For he does not wish his defeat and shame to be spread abroad, nor the glory of God and his saints to be recorded. For if we were to make an image of the invisible God, we would really sin; for it is impossible to depict one who is incorporeal and formless, invisible and uncircumscribable. And again: if we were to make images of human beings and regard them and venerate them as gods, we would be truly sacrilegious. But we do none of these things. For if we make an image of God who in his ineffable goodness became incarnate and was seen upon earth in the flesh, and lived among humans, and assumed the nature and density and form and color of flesh, we do not go astray. For we long to see his form; as the divine apostle says, "now we see puzzling reflections in a mirror."[4] For the image is a mirror and a puzzle, suitable to the density of our body. For the intellect, greatly tired, is not able to pass beyond the bodily, as the divine Gregory says.[5]

[3]Or: it is forbidden (the Greek could mean either).
[4]1 Cor 13:12.
[5]Gregory Nazianzen, *Hom.* 28.13 (ed. Gallay, 128). Cf. *Images*, I.11, III.2, 21.

3 (II.6) Away with you, envious devil, for you are envious of us, when we see the likeness of our Master and are sanctified by him, when we see all that he endured for our salvation and wonder at his descent to our condition, when we see his miracles and recognize and glorify the power of his divinity. You envy the saints the honor given them by God. You do not want us to see their glory recorded and become zealous for their courage and faith. You cannot bear the bodily and spiritual benefit that comes from faith in them. We are not persuaded by you, envious demon, hater of human kind. Hear, peoples, tribes, tongues, men, women, children, old men and women, youths and infants, the holy nation of Christians: if anyone proclaims to you anything other than the catholic Church has received from the holy Apostles and Fathers and synods and preserved up to now, do not listen to him nor accept the counsel of the serpent, as Eve accepted it and reaped death. If an angel, or an emperor, were to proclaim to you other than you have received, shut your ears. For the moment I hesitate to say, as the divine apostle said, "Let him be anathema!,"[6] for he may receive correction.

4 (II.7) But those, who do not search out the meaning of Scripture, say that God said through Moses the lawgiver, "Do not make any likeness, whether of things in heaven or of things on the earth,"[7] and through David the prophet, "Let those who venerate carved [images] be put to shame, those who boast in their idols,"[8] and many other similar passages. For whatever they allege from the divine scriptures and the holy Fathers, it is all with the same intention.

What therefore do we say to these? What else, save what was said by the Lord to the Jews: "Search the scriptures"? It is good to search the scriptures. But take care to do it with discretion. It is impossible, beloved ones, for God to lie. For there is one God, one

[6]Or: Let him be accursed! Gal 1:8–9.
[7]Cf. Exod 20:4; Deut 5:8.
[8]Ps 96:7.

lawgiver[9] of the Old and New Testaments, who of old spoke in many and various ways to the fathers by the prophets and in the last times by his Only-begotten Son. Pay careful attention. It is not my word. The Holy Spirit through Paul the holy apostle declares, "in many and various ways God spoke of old to the fathers by the prophets."[10] See that God spoke in many and various ways. For just as the physician knows not always to give the same remedy to all, but supplies to each one what is suitable, determining a medicine appropriate to place and disease and time, that is, season and condition and time of life, and therefore offers one thing to a baby, another to someone full grown, according to the time of life, one thing to the sickly, another to the healthy, and to each of those who are sickly not the same, but something in accordance with their condition and disease, and one thing in summer, another in winter, or autumn or spring, and in each place and in accordance with what is suitable to the place. So the best physician of souls prohibits from making images those who are still infants and ill with a diseased inclination to idolatry, apt to regard idols as gods and venerate them as gods and reject the veneration of God and offer his glory to the creation. For it is impossible to make an image of God who is incorporeal, invisible, immaterial and with neither shape nor circumscription nor apprehension; how can what cannot be seen be depicted? "No one has ever seen God; the Only-begotten Son, who is in the bosom of the Father, he has declared him,"[11] and "No one shall see my face, and live,"[12] said God.

5 (II.8) And that they did venerate idols as gods, listen to what Scripture says in the Exodus of the sons of Israel, when Moses went up on to Mount Sinai and was there for some time, waiting to receive

[9]The manuscripts give different readings here; most give the usual word (*nomothetēs*), but some (preferred by Kotter) give a different word (*nomodotēs*), one that stresses the element of giving, thus making a distinction between God and Moses, who has also been called lawgiver earlier on in this section.

[10]Heb 1:1–2.

[11]Jn 1:18.

[12]Exod 33:20.

the law from God, when the senseless people rose up against the servant of God, Aaron, saying, "Make us gods to go before us; as for this man, Moses, we do not know what has become of him."[13] Then, when they had taken off the ornaments of the women and melted them down, they ate and drank and became drunk with wine and illusion and, in their folly, began to play, saying, "These are your gods, Israel."[14] You see that they had idols as gods. For they did not make an idol of Zeus or one of the other gods, but, as it happened, they gave the gold to make an idol, whatever it might be, and there was set up an ox-headed image. So they took these images in cast metal for gods and venerated them as gods, images that were the dwelling-places of demons. And the divine apostle also says that they venerated the creation instead of the Creator: "they exchanged the glory of the incorruptible God for a corruptible human likeness and the likeness of birds and quadrupeds and reptiles and they worshipped the creation instead of the Creator."[15] For this reason, God prohibited any likeness.

6 (cf. I.4) I know what the One who cannot lie said: "the Lord your God is one Lord,"[16] and "you shall venerate the Lord your God and him alone shall you worship,"[17] and "there shall be for you no other gods,"[18] and "you shall not make any carved likeness, of anything in heaven or on the earth,"[19] and "all who venerate carved [images] shall be put to shame,"[20] and "gods who did not make heaven and earth, shall be destroyed,"[21] and these words in a similar manner: "God, who of old spoke to the fathers, has in these last days

[13]Cf. Exod 32:1.
[14]Exod 32:4.
[15]Cf. Rom 1:23, 25.
[16]Deut 6:4.
[17]Deut 6:13.
[18]Deut 5:7.
[19]Deut 5:8.
[20]Ps 96:7.
[21]Jer 10:11.

spoken to us in his Only-begotten Son, through whom he made the ages."[22] I know the One who said: "This is eternal life, that they might know you, the only true and living God and Jesus Christ, whom you sent."[23] And I believe in one God, the one beginning of all things, himself without beginning, uncreated, imperishable and immortal, eternal and everlasting, incomprehensible, bodiless, invisible, uncircumscribed, without form, one being beyond being, divinity beyond divinity, in three persons, Father and Son and Holy Spirit, and I worship this one alone, and to this one alone I offer the veneration of my worship. I venerate one God, one divinity, but also I worship a trinity of persons, God the Father and God the Son incarnate and God the Holy Spirit, not three gods but one, in persons, not divided but united. I do not offer three venerations, but one, not to each of the persons separately, but I offer one veneration to the three persons unitedly, as one God. I do not venerate the creation instead of the creator, but I venerate the Creator, created for my sake, who came down to his creation without being lowered or weakened, that he might glorify my nature and bring about communion with the divine nature. I venerate together with the King and God the purple robe of his body, not as a garment, nor as a fourth person (God forbid!), but as called to be and to have become unchangeably equal to God, and the source of anointing. For the nature of the flesh did not become divinity, but as the Word became flesh immutably, remaining what it was, so also the flesh became the Word without losing what it was, being rather made equal to the Word hypostatically. Therefore I am emboldened to depict the invisible God, not as invisible, but as he became visible for our sake, by participation in flesh and blood. I do not depict the invisible divinity, but I depict God made visible in the flesh. For if it is impossible to depict the soul, how much more the One, who gives the soul its immateriality?

22Heb 1:1–2.
23Jn 17:3.

7 (cf. I.5–7, II.8) But they say, God said through Moses the law-giver, "You shall venerate the Lord your God and him alone shall you worship," and "you shall not make any likeness, of anything in heaven or on the earth." Brothers, those who do not know the Scriptures truly err, for as they do not know that "the letter kills, but the Spirit gives life,"[24] they do not interpret the spirit hidden beneath the letter. To these I might rightly say, the One who taught you this taught also what follows. Learn, how the lawgiver interprets, when he says in Deuteronomy, "And the Lord spoke to you from the midst of the fire; you heard the sound of his words and you did not see any likeness, but only a voice," and a little later, "take good heed to your soul, for you did not see a likeness on the day, when the Lord spoke to you on Horeb in the mountain in the midst of the fire. Beware lest you act lawlessly and make for yourselves a carved likeness, any image, a likeness of a male or a female, a likeness of any beast that is upon the earth, a likeness of any winged bird" and so on, and after a little, "Beware lest you look up in the sky and see the sun and the moon and the stars and all the order of heaven, and being led astray venerate them and worship them."[25] You see that the single purpose of this is that one should not worship, or offer the veneration of worship, to creation instead of the Creator, but only to the One who fashioned all. Therefore everywhere it concerns worship by veneration. Again it says, "There shall be for you no other gods beside me, You shall not make for yourself a carved [image] nor any likeness, you shall not venerate them nor shall you worship them, for I am the Lord your God,"[26] and again "You shall tear down their altars, and break their pillars, and burn up the carved [images] of their gods with fire, for you shall not venerate any other god,"[27] and a little later "you shall not make for yourself any gods of cast metal."[28] You see,

[24]2 Cor 3:6.
[25]Deut 4:12, 15–17, 19.
[26]Deut 5:7–9.
[27]Exod 34:13–14.
[28]Exod 34:17.

how it was on account of idolatry that he prohibited the fashioning of images, and that it is impossible to depict God who is incommensurable and uncircumscribable and invisible. "For," it says, "you have not seen his form,"[29] just as also Paul, standing in the midst of the Areopagus, said, "Being then God's offspring, we ought not to think that the divine is like gold, or silver, or stone, a representation of human art and imagination."[30]

8 (cf. I.8) It was, therefore, for the Jews, on account of their sliding into idolatry, that these things were ordained by law. To speak theologically,[31] however, we, to whom it has been granted, fleeing superstitious error, to come to be purely with God, and having recognized the truth, to worship God alone and be greatly enriched with the perfection of the knowledge of God, and who, passing beyond childhood to reach maturity, are no longer under a custodian, have received the habit of discrimination from God and know what can be depicted and what cannot be delineated in an image. "For the law was our custodian until Christ came, that we might be justified by faith."[32] And "when we were children we were slaves to the elemental spirits of the universe";[33] "But now that faith has come, we are no longer under a custodian."[34] "For," it says, "you have not seen his form." What wisdom the legislator has! How could the invisible be depicted? How could the unimaginable be portrayed? How could one without measure or size or limit or form be drawn? How could the bodiless be depicted in color? How could one without shape be given shape? What therefore is this that is revealed and yet remains hidden? For it is now clear that you cannot depict the invisible God. When you see the bodiless become human for your

[29]Jn 5:37.

[30]Acts 17:29.

[31]That is, to speak in the manner of St Gregory the Theologian. The first part of this sentence follows *Hom.* 39.8.1–2 (ed. Moreschini, 162) quite closely.

[32]Gal 3:24.

[33]Gal 4:3.

[34]Gal 3:25.

sake, then you may accomplish the figure of a human form; when the invisible becomes visible in the flesh, then you may depict the likeness of something seen; when one who, by transcending his own nature, is incommensurable, without magnitude or size, that is, one who is in the form of God, taking the form of a slave, by this reduction to quantity and magnitude puts on the characteristics of a body, then depict him on a board and set up to view the One who has accepted to be seen. Depict his ineffable descent, his birth from the Virgin, his being baptized in the Jordan, his transfiguration on Tabor, what he endured to secure our freedom from passion, the miracles, symbols of his divine nature and activity, accomplished through the activity of the flesh, the saving tomb of the Savior, the resurrection, the ascent into heaven. Depict all these in words and in colors, in books and on tablets.

9 (II.9–10) And that these things are so, listen: "You shall not make for yourself any carved [image] or any likeness."[35] But these are the things that God commanded "they should make," it says: "the veil of the tabernacle of witness from aquamarine and porphyry and spun scarlet and twisted flax, woven work of the cherubim,"[36] and "they made the mercy seat above the ark and the two cherubim out of pure gold."[37] What are you doing, Moses? You say, "You shall not make for yourself a carved [image] or any likeness," and you fashion the veil, "a woven work of cherubim" and "two cherubim out of pure gold"? But listen, what the servant of God, Moses, answers you in his works. O blind and foolish, understand the power of what is said "and take good heed to your souls."[38] I said, "that you saw no likeness on the day in which the Lord spoke to you at Horeb on the mountain in the

[35]Deut 5:8.
[36]Exod 37:3 LXX; John's text is slightly different from the LXX, which reads "a work with cherubim woven in," which is closer to the Hebrew: cf., in English Bibles, Exod 36:8.
[37]Exod 38:5–6 LXX; cf. in English Bibles, Exod 37:6–7.
[38]Deut 4:15.

midst of the fire, lest you act lawlessly and make for yourselves a carved likeness, or any image,"[39] and "you shall not make for yourselves gods of cast metal."[40] I did not say, You shall not make an image of the cherubim that stand as slaves beside the mercy seat, but "you shall not make for yourself gods of cast metal," and "you shall not make any likeness" as of God, nor shall you worship "the creation instead of the Creator." Therefore I did not make a likeness of God, nor of anything else as God or human (for the nature of humanity is enslaved to sin), nor "did I worship the creation instead of the Creator." I made the tabernacle a likeness of the whole creation "according to the pattern shown me on the mountain"[41] and the cherubim overshadowing the mercy seat as standing before God. You know, how the purpose of Scripture is made clear to those who search intelligently. For it is necessary to know, beloved, that in every action truth and falsehood are to be sought out and the purpose of the one who acts, whether it is good or evil. For in the Gospel, God and angel and human being and earth and water and fire and air and the sun and the moon and stars and light and darkness and Satan and demons and serpents and scorpions and death and Hades and virtues and vices and everything that is good and bad are written about. But since what said about them is true and the purpose is the glory of God and our salvation and the glory of the saints glorified by him, the disgrace of the devil and his demons, all these we venerate and embrace and kiss with eyes and lips and cleave to in our hearts, likewise the whole of the Old and New Testaments and the words of the holy and select Fathers, but the shameful and filthy and unclean writing of the accursed Manichees we spit out and reject as containing the same names, but devised for the glory of the devil and his demons and their delight. So also in the matter of images, it is necessary to search out the truth and the purpose of those who make

[39]Deut 4:15–16.
[40]Exod 34:17.
[41]Exod 25:40; Heb 8:5.

them, and, if they turn out to be true and upright, promoting the glory of God and his saints, and inspiring virtue and driving away vice, and leading to the salvation of souls, then to accept and honor them as images and copies and likenesses and books and a memorial for the illiterate, and to venerate and kiss them with eyes and lips, and cleave to them in our hearts, as a likeness of God incarnate, or of his Mother, or of saints who shared in his sufferings and the glory of Christ, and were conquerors who overthrew the devil and the demons and their error, but if anyone dare to make an image of the immaterial and incorporeal divinity, we reject them as false. And anything to the glory and veneration and honor of the devil and the demons, we spit on and destroy by fire. And if anyone makes a god of an image of humans or beasts or birds or reptiles or any other creature, we anathematize him. For just as the holy Fathers destroyed the sacred places and temples of the demons and in their place raised up temples in the name of God and the saints, and we reverence them, so they destroyed the images of the demons and instead of them put up images of Christ and his Mother and the saints, and these we reverence. And of old, Israel neither set up temples in the name of human beings nor celebrated their memorial— for human nature was still under the curse and death was condemnation, therefore they were enjoined that one who even touched the body of someone dead was to be reckoned unclean— but now, since the divinity has been united without confusion to our nature, as a kind of lifegiving and saving medicine, our nature has been truly glorified and its very elements changed[42] into incorruption. Therefore temples are raised for them and images engraved.

10 (cf. II.11) Let everyone know, therefore, that anyone who attempts to destroy an image brought into being out of divine

[42]John uses a rather rare word here, *metastoicheioō*, literally "transelement," which has a variety of uses in the Fathers: to describe the resurrection body (Gregory of Nyssa), the transformed state of Christ's humanity (esp. Cyril of Alexandria) and the change in the eucharistic elements (Gregory of Nyssa).

longing and zeal for the glory and memorial of Christ, or of his Mother the holy *Theotokos*,[43] or of one of the saints, or yet for the disgrace of the devil and the defeat of him and his demons, and will not, out of longing for the one depicted, venerate or honor or greet it as a precious image and not as god, is an enemy of Christ and the holy Mother of God and the saints and a vindicator of the devil and his demons, and shows by his deed his sorrow that God and his saints are honored and glorified, and the devil put to shame. For the image is a triumph and manifestation and inscribed tablet in memory of the victory of the bravest and most eminent and of the shame of those worsted and overthrown. Many times I have seen those who long for someone, when they have seen his garment, greet it with their eyes and lips, as if it were the one longed for himself. It is necessary "to pay all of them their dues," in accordance with the holy apostle Paul, "honor to whom honor is due" and "to the emperor as supreme," and to rulers as appointed through them, to each according to the measure of his worth.

11 Where did you find clearly in the Old [Testament] or in the Gospel the name of the Trinity or *homoousion* or one nature of the divinity or three hypostaseis expressly or one hypostasis of Christ or two natures expressly? But nevertheless, since the holy Fathers define these [terms] from words found in Scripture that have the same force, we accept them and anathematize those who do not accept them. And I will show to you in the Old [Testament] that God prescribes the making of images, first of all the tabernacle itself and everything that is in it. And in the Gospels the Lord himself said to those who tempted him by asking if it was permissible to pay taxes to Cæsar, "Bring me a nomisma." And they showed him a denarion. And he asked them, "Whose image does it bear?" And they replied, "Cæsar's." And he said, "Give back to Cæsar what belongs to Cæsar,

[43]I have normally translated *Theotokos* as "Mother of God," but here, in apposition to "Mother," it would sound odd.

and to God what belongs to God."[44] Since it bears the image of
Cæsar, it is Cæsar's, and therefore give it back to Cæsar. If [it bears]
the image of Christ, give it back to Christ; for it is Christ's.

12 The Lord blessed his disciples, saying, "Many kings and
prophets longed to see what you see, and they did not see, and to
hear what you hear, and they did not hear. Blessed are your eyes,
because they see, and your ears, because they hear."[45] Therefore the
apostles saw Christ bodily and what he endured and his miracles and
they heard his words; we also long to see and to hear and to be
blessed. They saw face to face, since he was present to them bodily;
in our case, however, since he is not present bodily, even as we hear
his words through books and are sanctified in our hearing and
through it we are blessed in our soul, and venerate and honor the
books, through which we hear his words, so also through the depic-
tion of images we behold the form of his bodily character and the
miracles and all that he endured, and we are sanctified and assured,
and we rejoice and are blessed, and we revere and honor and vener-
ate his bodily character. Beholding his bodily form, we also under-
stand the glory of his divinity as powerful. For since we are twofold,
fashioned of soul and body, and our soul is not naked but, as it were,
covered by a mantle, it is impossible for us to reach what is intelligi-
ble apart from what is bodily. Just as therefore through words per-
ceived by the senses we hear with bodily ears and understand what
is spiritual, so through bodily vision we come to spiritual contem-
plation. For this reason Christ assumed body and soul, since human
kind consists of body and soul; therefore also baptism is twofold,
of water and the Spirit; as well as communion and prayer and
psalmody, all of them twofold, bodily and spiritual, and offerings of
light and incense.[46]

[44]Cf. Matt 22:15–22 and parallels.

[45]Cf. Lk 10:24 and Matt 13:16.

[46]Cf. Ps 140:1 ("let my prayer rise up like incense before you")? "Light and
incense" offered to icons: cf. the Definition of Nicæa II (Mansi 13.377E).

13 But leaving everything else alone, the devil directs his attack solely against the icons. And such is his envy of the icons, that in the *Spiritual Meadow* of St Sophronius, the patriarch of Jerusalem,[47] we find this story:

> Abba Theodore the Æliote said that there was a certain ascetic recluse on the Mount of Olives; the demon of fornication waged fierce battle against him. One day, therefore, when [the demon] attacked him vehemently, the elder began to give up in despair and to say to the demon, "How much longer are you not going to give in to me? From now on go away from me, lest we grow old together!" The demon appeared to him in visible form, saying, "swear to me that you will not tell anyone what I am about to say to you, and I will no longer fight against you." The elder swore, "By Him who dwells in the heavens I will not tell anyone what you say." The demon said to him, "Do not venerate this icon and I will no longer fight against you." The icon bore the likeness of our Lady, the holy Mary, the Mother of God, carrying our Lord Jesus Christ.[48]

Behold, those who prevent the veneration of icons imitate this [demon], and are his tools; for the demon of fornication would prefer the elder not to venerate the icon of our Lady than to fall into the impurity of fornication, knowing that this is a greater sin than fornication.

[47]John Moschus, *Spiritual Meadow*, 45 (PG 87.2900B-D; trans. Wortley, 35–6). The *Spiritual Meadow* is a collection of monastic stories, collected by John Moschus (c. 550–sometime between 619 and 634) and his Sophronius (c. 560–638), patriarch of Jerusalem from 634, in the last decade or so of the sixth century and completed about AD 600. It is in fact by John Moschus, though often attributed (as by John) to his more famous companion. The story is quoted at greater length in the florilegium that concludes *Images,* I (64).

[48]Kotter treats the rest of the chapter as part of the quotation from the *Spiritual Meadow,* but the citation ends here.

14 But since this discourse is about the image [or icon] and veneration, let us examine thoroughly this matter in more detail and ask:

Firstly, what is an image?

Secondly, what is the purpose of the image?

Thirdly, what different kinds of image are there?

Fourthly, what can be depicted in an image and what cannot be depicted?

Fifthly, who first made images?

15 Then, concerning veneration:

Firstly, what is veneration?

Secondly, how many kinds of veneration are there?

Thirdly, how many objects of veneration do we find in Scripture?

Fourthly, that all veneration takes place for the sake of God who is naturally worthy of veneration;[49]

Fifthly, that the honor offered to the image passes to the archetype.[50]

16 Firstly, what is an image?

An image is therefore a likeness and pattern and impression of something, showing in itself what is depicted; however, the image is certainly not like the archetype, that is, what is depicted, in every respect—for the image is one thing and what it depicts is another—and certainly a difference is seen between them, since they are not identical.[51] For example, the image of a human being may give expression to the shape of the body, but it does not have the powers of the soul; for it does not live, nor does it think, or give utterance, or feel, or move its members. And a son, although the natural image of a father, has something different from him, for he is son and not father.

[49]This expression, *ton physei proskynēton theon* is probably an allusion to Gal 4:8, which refers to *tois physei mē ousin theois.*

[50]These last two topics are discussed together, with no explicit reference back to the topics as listed here, in *Images,* III.41 (*pace* Kotter, note to III.15.8s).

[51]Literally: since this is not that nor that the other.

17 Secondly, what is the purpose of the image?

Every image makes manifest and demonstrates something hidden. For example, because human beings do not have direct[52] knowledge of what is invisible, since their souls are veiled by bodies, or [knowledge] of future events, or of things distant and removed in space, since they are circumscribed by space and time, the image was devised to guide us to knowledge and to make manifest and open what is hidden, certainly for our profit and well-doing and salvation, so that, as we learn what is hidden from things recorded and noised abroad, we are filled with desire and zeal for what is good, and avoid and hate the opposite, that is, what is evil.

18 Thirdly, what different kinds of image are there?

There are different kinds of image. The first kind is the natural image.[53] In each thing it is necessary that first there is what is by nature, and then what is contrived or by imitation, for example, first there is a human being by nature and then what is contrived by imitation. Therefore, the first natural and undeviating image of the invisible God is the Son of the Father, showing in himself the Father. "For no one has ever seen God,"[54] and again, "it is not the case that anyone has seen the Father."[55] That the Son is the image of the Father is affirmed by the apostle: "who is the image of the invisible God,"[56] and, [in his epistle] to the Hebrews, "who being the radiance of his glory and the express image of his person,"[57] and that he shows in himself the Father [we discover] in the Gospel according to John, when Philip says, "show us the Father and is it enough for us," and the Lord replies, "Have I been so long with you, and you have not known me, Philip? Whoever has seen me has seen the Father."[58] The

[52]Literally: naked.
[53]Cf. *Images*, I.9.
[54]Jn 1:18.
[55]Jn 6:46.
[56]Col 1:15.
[57]Heb 1:3.
[58]Jn 14:8–9.

Son is the Father's image, natural, undeviating, in every respect like the Father, save for being unbegotten and possessing fatherhood; for the Father is the unbegotten begetter, and the Son is begotten, not the Father. And the Holy Spirit is the image of the Son;[59] "for no one can say that Jesus is Lord, save in the Holy Spirit."[60] It is therefore because of the Holy Spirit that we know Christ, the Son of God, and God, and in the Son we behold the Father; for by nature the word [*logos*] is a messenger of mind [or meaning], and the spirit discloses the word.[61] The Spirit is therefore a like and undeviating image of the Son, being different only in proceeding; for the Son is begotten, but does not proceed. And of each father the son is a natural image. This is the first kind of image, the natural.

19[62] The second kind of image is the conception there is in God of what he is going to bring about, that is his pre-eternal will, which eternally holds sway in like manner; for the divine is unchangeable, and his will without beginning, by which, as is willed from before eternity, what has been determined comes to be at that time that has been predetermined by him. For his conception concerning each one of them contains images and paradigms of what he is to bring about, which are also called by Saint Dionysius predeterminations.[63] For in his will before they come to be there is shaped and imaged what he has predetermined and what will infallibly come to be.

[59]Cf. *On the Orthodox Faith* 13.75; also Athanasius, *To Serapion* 1.24.

[60]1 Cor 12:3.

[61]John is here alluding to the idea he uses elsewhere, derived from Gregory of Nazianzus and Maximus the Confessor, of a psychological image of the Trinity, consisting of mind, word and spirit (*nous, logos, pneuma*): see *On the Orthodox Faith*, 6–7, and even more clearly below *Images*, III.20, and Gregory Nazianzen, *Hom.* 23.11 (PG 35.1161C), Maximus, *Ambigua* 10.43 (PG 91.1196A), *Quæstiones et dubia* 105. This psychological trinity (also found in Gregory Palamas: see *CL Chapters*, 40) never attained the significance for Byzantine theology that Augustine's psychological images of the Trinity (see his *On the Trinity*, 9–10) did in the West.

[62]Cf. *Images*, I.10.

[63]Dionysius the Areopagite, *Divine Names* 5.8 (ed. Suchla, 188). Maximus also cites this passage: *Ambigua* 7 (PG 91.1085A).

20 [64] The third kind of image is that brought about by God through imitation, that is, human kind. For how will the creature be of the same nature as the uncreated save through imitation? For just as the intellect (the Father) and the word (the Son) and the Holy Spirit are one God, so also mind, word [or reason] and spirit are one human being, in respect of its being both self-determined [or: free] and sovereign; for God says, "Let us make human kind in accordance with our image and likeness," and immediately he added, "and let them rule over the fish of the sea and the birds of the sky,"[65] and again "and you shall rule over the fish of the sea and the birds of the sky and all the earth and you shall exercise dominion over it."[66]

21 (cf. I.11) The fourth kind of image is the use in Scripture of shapes and forms and figures to convey a faint conception of God and the angels by depicting in bodily form what is invisible and bodiless, because we cannot behold the bodiless without using shapes that bear some analogy to us, as Dionysius the Areopagite says, who had great insight in matters divine.[67] For someone might say that, if forms for formless things and shapes for shapeless things are proposed, not the least reason is because our analogies are not capable of raising us immediately to intellectual contemplation but need familiar and natural points of reference.[68] If then the divine Word, foreknowing our need for analogies and providing us everywhere with something to help us ascend, applies certain forms to those things that are simple and formless, how may not those things be depicted which are formed in shapes in accordance with our nature, and longed for, although they cannot be seen owing to their absence? The divinely eloquent Gregory therefore says that the intellect, tiring of trying to get past all things corporeal, realizes its

64Cf. *Images*, II.20.
65Gen 1:26.
66Cf. Gen 1:28.
67Cf. Dionysius the Areopagite, *Celestial Hierarchy*, 1.1.3 (ed. Heil, 8).
68Cf. idem, *On the Divine Names*, 1.4 (ed. Suchla, 114).

impotence;[69] but "the invisible things of God, since the creation of the world, have been clearly perceived through the things that have been made."[70] For we see images in created things intimating to us dimly reflections of the divine; as when we say that there is an image of the holy Trinity, which is beyond any beginning, in the sun, its light and its ray, or in a fountain welling up and the stream flowing out and the flood, or in our intellect and reason and spirit, or a rose, its flower and its fragrance.

22 (cf. I.12) The fifth kind of image is that which prefigures and portrays beforehand what is to come, as the [burning] bush[71] and the rain on the fleece[72] prefigure the Virgin Mother of God, as also the rod[73] and the jar,[74] or as the serpent prefigures those who have overcome the bite of the primordially evil serpent through the cross,[75] or the sea, the water and the cloud prefigure the spirit in baptism.[76]

23 (cf. I.13) The sixth kind of image is to arouse the memory of past events, whether wonders or acts of virtue for the glory and honor and memorial[77] of the bravest and of those who excel in virtue, or acts of wickedness for the scandal and shame of the most wicked men, for the benefit of those who later behold them, so that we may flee what is wicked and be zealous for the virtues. This kind of image is twofold: through words written in books—for letters depict the word, as God engraved the Law on tablets and ordered the lives of men beloved of God to be recorded—and through things seen by the

[69]Gregory Nazianzen, *Hom.* 28.13 (ed. Gallay, 128). Cf. *Images*, II.5, III.2, 21.
[70]Rom 1:20.
[71]Cf. Exod 3:2–6.
[72]Cf. Ps 71:6 LXX (Kotter cites Judg 6:38, but it is not so exact).
[73]Cf. Num 17:23 (17:8).
[74]Cf. Exod 16:33.
[75]Cf. Num 21:8–9 and Jn 3:14.
[76]Cf. Exod 14:19–29 and 1 Cor 10:1–4.
[77]This word, *stylographia*, occurs in the inscriptions of certain psalms (e.g., Pss 15, 55, 56, 57, 58, 59), and is transliterated in English versions as "Miktam."

sense of sight, as when he ordered the jar and the rod to be placed in the ark as an eternal memorial,[78] and commanded the names of the tribes to be engraved on the stones of the ephod,[79] but also that the twelve stones should be carried from the Jordan as a figure of the priests—what a mystery! to the faithful in truth the very greatest—who carried the ark and of the cutting off of the water.[80] So now we record the images of virtuous men of the past for emulation and remembrance and to arouse our zeal. Therefore, either destroy every image and establish laws against the One who ordered that these things should be, or receive each in the reason and manner fitting to each.

24 Fourth chapter: what is to be depicted and what is not to be depicted, and how is anything depicted?

Bodies can reasonably be depicted, as having shape and bodily outline and color. Angels and souls and demons, if without body or density, may yet be given shape and outline in accordance with their nature—for being intellectual, they are believed to be and act intellectually in intellectual places—they are therefore depicted in bodily form, as Moses depicted the cherubim, and as they were beheld by those worthy, the bodily image disclosing a certain incorporeal and intellectual vision. The divine nature is alone uncircumscribable and completely incomprehensible, without form or shape, and if the divine Scripture bestows on God figures that seem to be bodily, as shapes are seen, yet they are in a way incorporeal; for they were seen, not with bodily, but with intellectual eyes, by the prophets to whom they were revealed, for they were not seen by all. To put it simply: we can make images of everything with a visible shape; we understand these things, just as they are seen. For if it is from words that we understand shapes, but from what we have seen that we also

[78]Cf. Heb 9:4.
[79]Cf. Exod 28:9–12.
[80]Cf. Jos 4:3–8.

come to an understanding of these things, so it is also with each of
the senses, from what we smell or taste or touch, we come to under-
stand these things through words.

25 We know therefore that the nature of neither God nor angel nor
soul nor demon can be seen, but by a certain transformation these
beings are beheld, since the divine providence bestows figures and
shapes upon beings that are incorporeal and without figure or any
bodily shape so that we might be guided to an approximate and par-
tial knowledge of them, lest we remain in complete ignorance of
God and the incorporeal creatures.

For God is by nature completely incorporeal; angels and souls
and demons, in comparison with the alone incomparable God, are
bodily, but in comparison with material bodies are incorporeal.
God, therefore, not wishing that we should be completely ignorant
of the incorporeal beings, bestowed on them figures and shapes and
images that bear some analogy with our nature, bodily shapes seen
by the immaterial sight of the intellect, and we depict these beings
and give them shapes, just as the cherubim were depicted and given
shapes. But Scripture has shapes and images of God, too.

26 Who first made images?

God himself first begat his Only-begotten Son and Word, his liv-
ing and natural image, the exact imprint of his eternity; he then made
human kind in accordance with the same image and likeness. And
Adam saw God and heard the sound of his feet, as he walked in the
evening, and he hid himself in paradise;[81] and Jacob saw and wres-
tled with God[82]—it is clear that God appeared to him as a man—and
Moses saw him as a human back,[83] and Isaias saw him as a man
seated on a throne,[84] and Daniel saw the likeness of a man, and as a

[81]Cf. Gen 3:8.
[82]Cf. Gen 32:25–31 (English Bibles: 32:24–30).
[83]Cf. Exod 33:23.
[84]Cf. Isa 6:1.

son of man coming upon the ancient of days.[85] No one, however, saw the nature of God, but the figure and image of one who was yet to come. For the invisible Son and Word of God was about to become truly human, that he might be united to our nature and seen upon earth. All those, therefore, who saw the figure and image of the One who was to come venerated him, as Paul the Apostle says in the Epistle to the Hebrews, "All these died in faith, not having obtained the promises, but have seen and greeted them from afar."[86] Should I not, therefore, make an image of the one who appeared for my sake in the nature of flesh, and venerate and honor him with the honor and veneration offered to his image? Abraham did not see God's nature ("for no one has ever seen God"),[87] but the image of God and falling down he venerated him.[88] Jesus the son of Nave did not see the nature of an angel, but its image (for the angelic nature cannot be seen by bodily eyes) and falling down he venerated him,[89] likewise also Daniel (for an angel is not God, but God's creature and slave and attendant), he venerated him, not as God, but as God's attendant and servant.[90] And should I not make images of the friends of Christ, and should I not venerate them, not as gods, but as images of God's friends? For neither Jacob nor Daniel venerated the angels who appeared to them as gods, neither do I venerate the image as God, but through the images of his saints I offer veneration and honor to God, for whose sake I reverence his friends also, and this I do out of respect [for them]. God was not united to the angelic nature, but to human nature. God did not become an angel, but in nature and truth God became a human being. "For God did not take on him [the nature of] angels, but he took on him the seed of Abraham."[91] The Son of God did not become

[85]Cf. Dan 7:13.
[86]Heb 11:13.
[87]Jn 1:18.
[88]Cf. Gen 18:1–3.
[89]Cf. Jos 5:13–15.
[90]Cf. Dan 8:15–17, 10:7–21.
[91]Heb 2:16 (the following comments by John suggest that this is how he took the verse, in contrast with the translation found in, e.g., the RSV).

an angelic nature hypostatically; the Son of God became hypostatically a human nature. Angels do not participate in, nor do they become sharers in, the divine nature, but in divine activity or grace; human beings, however, do participate in, and become sharers of, the divine nature, as many as partake of the holy Body of Christ and drink his precious Blood; for it is united to the divinity hypostatically, and the two natures are hypostatically and inseparably united in the Body of Christ of which we partake, and we share in the two natures, in the body in a bodily manner, and in the divinity spiritually, or rather in both in both ways, not that we have become identical [with God] hypostatically (for we first subsisted, and then we were united), but through assimilation with the Body and the Blood. And how are those who through the keeping of the commandments preserve their union pure not greater than the angels? Our nature is a little lower than the angels because of death and the grossness of the body, but through God's favor and union with him it has become greater than the angels. For the angels stand with fear and trembling before [that nature] seated on the throne of glory in Christ, and they will stand trembling at the judgment. It is not said of them in Scripture that they will be seated together with, or be partakers of, the divine glory ("for they are all ministering spirits sent forth to serve, for the sake of those who are to inherit salvation"),[92] not that they will reign together, nor that they will be glorified together, nor that they will sit at the Father's table, but the saints are sons of God, sons of the kingdom and heirs of God and fellow-heirs with Christ. Therefore, I honor the saints and I glorify them together with Christ as his slaves and friends and fellow-heirs: slaves by nature, friends by choice, and sons and heirs by divine grace, as the Lord said to the Father.[93]

[92]Heb 1:14.

[93]For this discussion of the relationship between angels and humans, cf. the discussion in John's treatise *On the Two Wills of Christ*, 16, 30, where he argues (in terms that anticipate the teaching of St Gregory Palamas in *CL Chapters*, 62–64) that, whereas the angels are superior to humans by virtue of possessing the image of God

Having discussed the image, let us speak also about veneration, and first ask, what veneration is.

27 Concerning veneration: what is veneration?

Veneration accordingly is a sign of submission, that is of subordination and humility.[94] The kinds of veneration are several.

28 How many kinds of veneration are there?

The first kind of veneration is that of worship, which we offer to God, who is alone venerable by nature,[95] and this itself has several forms. The first is that of service;[96] for all creatures venerate him, as servants do their master, for "all things," it says, "are your servants,"[97] some voluntarily, some involuntarily. Those who worship him voluntarily with knowledge are the pious, those who acknowledge him and involuntarily worship against their will are the demons;[98] others who do not know the one who is God by nature worship involuntarily him of whom they are ignorant.

29 The second kind [of worship] is that of wonder and desire, in accordance with which we venerate God because of his natural glory. For he is alone to be glorified who does not receive glory from any other, but is himself the source of all glory and the incomprehensible light of all goodness, incomparable sweetness, irresistible beauty, abyss of goodness, wisdom past finding out, infinite

more purely, inasmuch as part of the meaning of the image is found in the soul's rule of the body reflecting God's rule of the cosmos, in that respect humans are superior to angels. But the way John develops here what is entailed by our having bodies, that by virtue of reception of the Eucharist and consequent deification, humans are superior to angels, seems to be unparalleled.

[94]The Greek word *proskynesis* suggests a bodily action of bowing down to the ground.

[95]Cf. Gal 4:8, with its reference to "those who by nature are not gods."

[96]Or "slavery" (*douleia*).

[97]Ps 118:91.

[98]Cf. Jas 2:19.

power, alone worthy to be wondered at, venerated, glorified and desired.

30 The third kind [of worship] is that of thanksgiving for the good things that have befallen us; for all beings need to thank God and to offer him everlasting veneration, because all things have their being from him,[99] and subsist in him,[100] and without envy he distributes his own gifts to all without being asked,[101] and he wills all to be saved[102] and participate in his own goodness, and he is long-suffering with us when we sin,[103] and causes the sun to rise on the just and the unjust, and makes it rain on the wicked and the good,[104] and because the Son of God for our sake became as we are and made us sharers of the divine nature,[105] that "we might be like him," as John the Theologian says in the catholic epistle.[106]

31 The fourth kind [of worship] springs from our neediness and hope in his kindnesses, so that accordingly we recognize that, as we cannot do or have anything good without him,[107] each of us venerates him, begging him for that of which we feel the need and which we desire, to be saved from evils and obtain good things.

32 The fifth kind [of worship] is that of repentance and confession; for when we have sinned we venerate God and fall down before him, begging him to forgive our failings as prudent servants. And this kind [of worship] is threefold: for someone may grieve out of love, or because he may not obtain God's kindnesses, or in fear of

[99]Cf. Rom 11:36.
[100]Cf. Col 1:17.
[101]Cf. Wis 7:13.
[102]Cf. 1 Tim 2:4.
[103]Cf. 2 Pet 3:9.
[104]Cf. Matt 5:45.
[105]Cf. 2 Pet 1:4.
[106]1 Jn 3:2.
[107]Jn 15:5.

punishment. The first arises from prudence and his desire for God and a filial disposition, the second is that of a hireling, the third that of a slave.[108]

33 How many objects of veneration do we find in Scripture, and in how many ways do we offer veneration to creatures?

First, then, those upon whom God rests, who is alone holy and "rests among the saints,"[109] like the holy Mother of God and all the saints. These are those who, through their own choice and the indwelling and cooperation of God, have become assimilated to God as much as possible, who are truly called gods, not by nature, but by adoption, as iron heated in the fire is called fire, not by nature, but by its condition and participation in fire. For he says, "You shall be holy, because I am holy."[110] First, then, choice. Then, with everyone who chooses the good God cooperates for the good, then "I shall dwell in them and walk among them,"[111] and "we are temples of God and the Spirit of God dwells in us,"[112] then "he gave them authority over unclean spirits, to cast them out and heal every sickness and weakness,"[113] and "I do such things, and you will do them, and greater things than these will you do,"[114] "As I live, says the Lord,"[115] "but I will glorify those who glorify me,"[116] "if we suffer with him, that we may also be glorified together with him,"[117] and "God stood in the assembly of gods, in their midst he judges the gods."[118] Just as

[108]This threefold classification of our relationship to God—those who love God as sons, serve him as hirelings for reward, or fear him as slaves fear punishment—is a traditional theme in the Fathers, and goes back at least to Philo (see his *On Abraham*, 128–30).

[109]Isa 57:15 (it could be translated: "rests in the holy places [or: the sanctuary]").

[110]Lev 19:2; 1 Pet 1:16.

[111]2 Cor 6:16; cf. Lev 26:12.

[112]Cf. 1 Cor 3:16.

[113]Matt 10:1.

[114]Cf. Jn 14:12.

[115]Cf. Isa 49:18, and elsewhere in the prophets, especially Ezekiel.

[116]1 Kgd 2:30.

[117]Rom 8:17.

[118]Ps 81:1.

they are truly gods, not by nature, but as partakers of God's nature, so they are to be venerated, not by nature, but as having in themselves that which is venerable by nature, just as iron plunged in fire is not by nature unapproachable to touch and capable of burning, but as by participating in that which is by nature capable of burning. Therefore they are venerated as glorified by God, as those whom God has made terrible to their opponents and benefactors to those who approach them in faith, not as those who are by nature gods and benefactors, but as attendants on God and his servants, who out of love have been granted the good fortune of addressing him. We therefore venerate them, since the king is honored when he sees one whom he loves venerated and honored, not as a king, but as an obedient servant and well-disposed friend. And those who approach in faith obtain their requests, either when his attendant requests this from the king, or when the king acknowledges the honor and faith of him who seeks from his attendant; for it was through him that he made his request. So those who approached the apostles received healings. Thus from the shadow[119] and the handkerchiefs and aprons[120] of the apostles there gushed forth healings.[121] Those who rebelliously and like apostates wish to be venerated like gods are not worthy of veneration and are fit for eternal fire. And those who contemptuously and with a proud mind will not venerate the servants of God are to be condemned as imposters and proud, and as devoid of piety towards God. Witness the children who contemptuously jeered at Eliseus and became food for bears.[122]

34 The second kind [of veneration] is that whereby we venerate creatures, through whom and in whom God worked our salvation,[123] either before the coming of the Lord, or in his incarnate dispensation, such as Mount Sinai and Nazareth, the manger in Bethlehem

[119]Cf. Acts 5:15.
[120]Cf. Acts 19:12.
[121]Cf. *Images*, I.22.
[122]Cf. 4 Kgd 2:23–24.
[123]Cf. *Images*, I.16.

and the cave, the holy place of Golgotha, the wood of the cross, the nails, the sponge, the reed, the holy and saving lance, the apparel, the tunic, the linen cloths, the winding sheet, the holy tomb, the fountain head of our resurrection, the gravestone, Sion the holy Mount, and again the Mount of Olives, the sheep gate[124] and the blessed precinct of Gethsemane. These and suchlike I reverence and venerate and every holy temple of God and every place in which God is named, not because of their nature, but because they are receptacles of divine energy and in them God was pleased to work our salvation. And I reverence angels and human beings and all matter participating in divine energy and serving my salvation, and I venerate them because of the divine energy. I do not venerate Jews, for they are not partakers of the divine energy, nor was it with a view to my salvation that they crucified the Lord of Glory, my God,[125] but rather impelled by envy and hatred towards God who works goodness. "Lord, I have loved the majesty of your house," says David, "and the place of the tabernacle of your glory,"[126] and "you shall worship in the place where his feet have stood,"[127] "and worship in his holy mountain."[128] The holy Mother of God is the living holy mountain of God, and the apostles the rational mountains of God; "the mountains skipped like rams, and the hills like lambs of sheep."[129]

35 The third kind [of veneration] is that whereby we venerate things dedicated to God, by which I mean the sacred Gospels and the other books [of Scripture]; "they were written down for our instruction, on whom the ends of the ages have come."[130] It is clear, then,

[124]Cf. Jn 5:2.
[125]Cf. 1 Cor 2:8.
[126]Ps 25:8.
[127]Ps 131:7.
[128]Ps 98:9 (the verb translated "worship" in these two verses from Psalms is cognate with the noun [*proskynesis*] translated "veneration," not the noun translated "worship" [*latreia*]).
[129]Ps 113:4.
[130]1 Cor 10:11.

that patens and chalices, thuribles, lamps and tables: all these are to be reverenced. For see, when Baltasar made the people serve from the sacred vessels, how God destroyed his kingdom.[131]

36 The fourth kind [of veneration] is that whereby the images seen by the prophets were worshipped and also the images of things to come (for it was through a vision of images that they saw God), as Aaron's rod[132] was an image of the mystery of the Virgin, and also the jar[133] and the table;[134] and when Jacob bowed in veneration over the head of his staff,[135] it was a figure of the Savior. Yet these images of what is past serve for remembrance; for the tabernacle itself was an image of the whole cosmos (for "behold," he said to Moses, "the figure shown to you on the mountain"),[136] together with the golden cherubim, a work in cast metal,[137] and the cherubim woven into the veil.[138] So we venerate the precious figure of the cross, and the likeness of the bodily form of my God, and of her who bore him in the flesh, and of his attendants.

37 The fifth kind [of veneration] is that whereby we venerate one another as having a portion of God[139] and having come to be in the image of God,[140] humbling ourselves before one another and fulfilling the law of love.[141]

[131]Cf. Dan 5:3–4, 30. King Baltasar (called Belshazzar in English Bibles) is also seen as a type of the iconoclast Emperor Leo III in the *Life of St Stephen the Younger* 9 (Auzépy 1996, 98, l. 23, and 190, n. 55).

[132]Cf. Num 17:23 (8).

[133]Cf. Exod 16:33.

[134]Cf. Exod 25:23.

[135]Cf. Gen 47:31 LXX.

[136]Exod 25:40; Heb 8:5.

[137]Cf. Exod 25:18.

[138]Cf. Exod 26:31.

[139]Cf. Gregory Nazianzen, *Homily*, 14.7 (PG 35.865C).

[140]Cf. Gen 1:26.

[141]Cf. Rom 13:8.

38 The sixth kind [of veneration] is that towards those in positions of rule and authority (for he says, "Pay to all of them your dues, ... honor to whom honor is due"),[142] as Jacob venerated Esau as the brother born before him and Pharaoh as a ruler appointed by God.[143]

39 The seventh kind [of veneration] is that whereby slaves [venerate] their masters, and the needy their benefactors, who meet their needs, as Abraham [venerated] the sons of Emmor, when he acquired a cave as a double [inheritance].[144]

40 In a word, veneration offered out of fear or desire or honor is a symbol of submission and humility, but no one is to be worshipped as God, except the one who is alone God by nature,[145] to all others what is due is reckoned for the Lord's sake.

41 See, how much strength and what divine energy is given to those who with faith and a pure conscience approach the images of the saints. Let us, therefore, brothers, stand on the rock of faith and in the tradition of the Church, not removing the boundaries, which our holy fathers set in place,[146] nor giving space to those who wish to innovate or break up the structure of God's holy, catholic and apostolic Church. For if license is given to anyone who wishes, little by little the whole body of the Church will be broken up. No, brothers, no, children of the Church who love Christ, let us not put our mother to shame, let us not destroy her comeliness. Accept her in the preeminence I have defended. Learn what God says about her: "You

[142]Rom 13:7.

[143]Esau: Gen 33:3. In his encounter with Pharaoh, Jacob did not bow down, but blessed him: cf. Gen 47:7–10. Cf. *Images*, I.8.

[144]John is following the account in Acts 7:16, which conflates Gen 23:7 and 33:19–20: cf. *Images*, I.8, n. 22. The account here is also very condensed, and the translation above relies on the fuller account in I.8.

[145]Cf. Gal 4:8.

[146]Cf. Prov 22:28.

are all fair, my neighbor, and there is no blemish in you."[147] Let
us venerate and worship, as God to be venerated by nature,[148] the
only creator and fashioner. And let us venerate the holy Mother
of God, not as God, but as the mother of God according to the
flesh. Furthermore, let us venerate the saints as God's chosen friends,
who have the right to appear before him. For if to kings, who are
destined for corruption and often enough are impious and sinners,
and also to rulers appointed by them, and to images of these men,
wreathed with laurel, human beings offer veneration, in accordance
with the divine word of the Apostle: "Be submissive to rulers and
authorities,"[149] and "Pay all of them their dues, . . . fear to whom fear
is due, honor to whom honor is due,"[150] and "Render to Cæsar the
things that are Cæsar's," as the Lord says, "and to God the things
that are God's,"[151] how much more is it not necessary to venerate
the Lord of Lords, as alone wielding dominion by nature, and also
his slaves and friends, who have conquered the passions and been
appointed rulers of all the earth ("For you will appoint them,"
says David, "rulers over all the earth"),[152] and have received author-
ity over demons and diseases,[153] and reign together with Christ
with a kingship incorruptible[154] and unbreakable, whose mere
shadow drives away diseases and demons?[155] Should we reckon the
image to be weaker and less honorable than a shadow, for it truly
depicts the archetype?[156] Brothers, faith is essential to the Christian.
The one who draws nigh with faith gains many things; "he who
doubts is like a wave of the sea that is driven and tossed by the

[147]Cant 4:7.
[148]Cf. Gal 4:8.
[149]Titus 3:1.
[150]Rom 13:7.
[151]Matt 22:21.
[152]Ps 44:17.
[153]Cf. Lk 9:1.
[154]Cf. Dan 7:14.
[155]Cf. Acts 5:15.
[156]There is a play on words here between "shadow" (*skia*) and "depicts" (*skio-grapheō*).

wind,"[157] he will not receive anything. But all the saints are well pleasing to God through faith. Let us receive then the tradition of the Church in uprightness of heart and not with much discussion; for God made human beings upright, but they seek after much discussion. Let us not allow ourselves to learn a new faith, as if sitting in judgment on the tradition of the holy Fathers. For the divine Apostle says, "If anyone is preaching to you a gospel contrary to that which you received, let him be accursed."[158] We therefore venerate the images, not by offering veneration to matter, but through them to those who are depicted in them. "For the honor offered to the image mounts up to the archetype," as the divine Basil says.[159]

42 You, O most sacred flock[160] of Christ, a people named after Christ, a holy nation,[161] the body of the Church,[162] may Christ fill with the joy of his resurrection and make you worthy to follow the footsteps of the holy shepherds and teachers of the Church, advancing to gain among the radiance of the saints[163] his glory, which you all may attain by his grace, glorifying him eternally together with the Father who is without beginning, to whom be glory to the ages of ages. Amen.

Having spoken of the difference between idols and images, and having taught the definition of images, behold we now bring forward the [patristic] citations, as we have undertaken.

[157]Jas 1:6.

[158]Gal 1:9.

[159]This familiar quotation from St Basil is here quoted in a slightly different form: "mounts up" rather than "passes to" (*anabainei* instead of *diabainei*).

[160]Cf. Lk 12:32.

[161]Cf. 1 Pet 2:9.

[162]Cf. Col 1:18 (*tou somatos tes ekklesias* is usually taken as two nouns in apposition, "the body, the Church," but it could equally be taken as translated above; if *ekklesias* were taken as an epexegetic genitive, it would make no difference in meaning).

[163]Cf. Ps. 109:3 LXX.

43 Saint Dionysius, bishop of Athens, from the letter to John the Apostle and Theologian:[164]

Truly visible things are manifest images of invisible things.

44 (I.32, II.28) The same, from *On the Ecclesiastical Hierarchy*:[165]

But the beings and orders that are above us, of which we have already made sacred mention, are bodiless, and their hierarchy is intelligible and transcends the cosmos. Let us see our hierarchy, in a way that bears analogy with us, made manifold by a multitude of symbols of things perceived by the senses, by which we ascend hierarchically, according to our measure, to the single-formed deification, to God and to divine virtue, those [beings] understanding, as intellects, in a way permitted to them, while we ascend by means of images perceived through the senses to the divine contemplations.

45 (cf. II.29, I.33) *Comment*: If, in a way that bears analogy with us, we are led by images perceived through the senses to divine and immaterial contemplation and, out of love for human kind, the divine providence provides figures and shapes of what is without shape or figure, to guide us by hand, so to say, why is it unfitting, in a way that bears analogy with us, to make an image of one who submitted to shape and form and was seen naturally as a man out of love for human kind?

46 (I.34, II.30) Saint Basil, from his homily on the blessed Barlaam the Martyr, which begins: "First the death of the saints . . .":[166]

Rise up now for me, O radiant painters of athletic achievements, and magnify the mutilated image of the general by your arts. The context in which he was crowned, described more dimly by me, you make radiant with the colors of your wisdom. Overwhelmed by you,

[164]Dionysius the Areopagite, *ep.* 10 (ed. Ritter, 208).
[165]Idem, *On the Ecclesiastical Hierarchy* 1.2 (ed. Heil, 65).
[166]Basil, *Hom. on Barlaam the Martyr* (PG 31.489AB), also cited at Nicæa II.

I will refrain from describing the martyr's deeds of valor. Beaten by your strength, I rejoice today in such a victory. I see the struggle depicted most exactly by you, with his hand in the fire; I see the combatant, radiant with joy, depicted in your image. Let the demons howl, as they are now struck down by the valiant deeds of the martyrs now manifest in you. Let the burning hand be once again shown as victorious over them. May Christ, the judge of the context, inscribe them on his list, to whom be glory to the ages.

47 (I.46, II.42) The same, from the homily on the forty saints:[167]

Moreover, both writers of words and painters many times describe clearly human deeds of valor in war, the former adorning them with rhetoric, the latter inscribing them on tablets, and both arousing many to deeds of excellence. For what the word of a story makes present through hearing, the very same is shown silently in a picture through imitation.

48 (I.35, II.31) The same, from the thirty chapters to Amphilochius on the Holy Spirit, chapter 17:[168]

Because the image of the emperor is called the emperor, and yet there are not two emperors, for neither is the power divided nor the glory shared. For as the principle and authority that rules over us is one, so also is the praise that we offer one and not many, because the honor offered to the image passes to the archetype. What the image is by imitation here below, there the Son is by nature. And just as with works of art the likeness is in accordance with the form, so with the divine and incomposite nature the union is in the communion of the divinity.

49 *Comment:* Therefore, just as "he who does not honor the Son," as the Lord says, "does not honor the Father who sent him,"[169] so also

[167]Idem, *Hom. on the 40 Martyrs of Sebaste* (PG 31.508D–509A).
[168]Idem, *On the Holy Spirit*, 18.45.15–23 (ed. Pruche, 406); also (partially) cited at Nicæa II.
[169]Jn 5:23.

he who does not honor the image does not honor the one depicted. But perhaps someone will say, It is necessary to honor the image of Christ, but not that of the saints. Oh, what folly! Hear the Lord speaking to his disciples: "He who receives you receives me."[170] So one who does not honor the saints does not honor the Lord himself.

50 (I.52, II.48) Saint Gregory of Nyssa, from his homily, preached at Constantinople, on the divinity of the Son and the Spirit, and concerning Abraham, homily 44, which begins: "Just as those who love to behold such things are affected by meadows decked with flowers . . .":[171]

First then the father binds his child. I have often seen images of this tender scene in pictures and I have not been able to pass from seeing it without tears, so skillfully does the artist bring this story to my sight. Isaac is before us, crouching on his knee before the altar, with his hands tied behind his back; [his father] has seized him from behind with his knee bended, and with his left hand grasping the child's hair he pulls him towards himself and bends over the face that looks up to him piteously, and with a sword in his right hand he proceeds directly to the sacrifice. The edge of the sword has already touched his body, and then there comes to him a voice from God forbidding the deed.

51 (I.53, II.49) Saint John Chrysostom, from his interpretation of the Epistle to the Hebrews:[172]

In a certain way the first is an image of the second, Melchisedek [an image] of Christ, just as one might say that a sketch of a picture is a shadow of the picture in colors; therefore the law is called a shadow, grace truth, and reality what is to come. So the law and

[170]Matt 10:40.
[171]Gregory of Nyssa, *On the Divinity of the Son and the Holy Spirit* (ed. Rhein, 138–9); cited at Nicæa II.
[172]John Chrysostom, passage unidentified (cf., however, *Homily* 12 *on Hebrews*, ed. Field, vol. 7, 150f.).

Melchisedek are preparatory sketches of the picture in colors, and grace and truth are that picture in colors, while reality belongs to the age to come, just as the Old [Testament] is a type of a type, and the New [Testament] a type of reality.

52 (I.58, II.54) Severian, bishop of Gabala,[173] from the homily on the dedication of the Cross:[174]

How does the image of the accursed one bring life to our forefathers?

And a little further on:

How does the image of one accursed bring salvation to a people storm-tossed by misfortune? Now would it not be more credible to say: If any of you is bitten, look to the heaven above, to God, or into the tabernacle of God, and be saved? But passing over these, he fixes only on the image of the Cross. Why therefore did Moses do these things, when he said to the people, "Do not make for yourselves anything carved or of cast metal or a likeness of anything, whether in heaven above or in the earth beneath or in the waters under the earth"?[175] But why do I utter these things to someone ungrateful? Tell me, O most faithful servant of God, do you make what you forbid? Do you fashion what you overthrow? You who say "You shall not make anything carved," who overturned the molten calf, do you fashion a serpent in bronze? And this not secretly, but openly, known to all? But those things, he says, I laid down by law, that I might cut off the occasions of irreverence and lead the people from all apostasy and worship of idols; but now I cast a serpent usefully for a prefiguration of the truth. And just as I established the tabernacle and everything in it and spread out in the sanctuary the cherubim, a likeness of things invisible, as a type and shadow of things to come, so I set up the serpent for the salvation of the people, that through their

[173]Severian was bishop of Gabala in the early fifth century, and was one of the leading opponents of St John Chrysostom at the Synod of the Oak (AD 403).

[174]From Severian's *Homily on the Serpent* (PG 56.499–516).

[175]Exod 20:4.

experience of these things they might be prepared beforehand for the image of the sign of the Cross and upon it the Savior and Redeemer. And that this explanation is entirely without deceit, beloved, hear the Lord confirming this when he said, "And just as Moses lifted up the serpent in the desert, so must the Son of man be lifted up, that everyone who believes in him may not perish, but have eternal life."[176]

53 (I.60, II.56) That the invention of images is nothing new, but an ancient practice, known and familiar to the holy and elect Fathers, listen to this: It is written in the life of Basil the Blessed by his disciple and successor in the see, Helladius, that the saint was standing in front of an icon of Our Lady, in which there was depicted a figure of the ever-praised martyr, Mercurius; he stood, praying for the overthrow of the most godless and apostate tyrant, Julian. From this icon he learnt this revelation: for he saw that for a little while the martyr disappeared, and not long afterwards [he reappeared] holding a blood-stained spear.[177]

54 (I.61, II.57) In the *Life of John Chrysostom* it is written in these very words:[178]

The blessed John loved very much the epistles of the most wise Paul.

And a little further on:

[176]John 3:14–15.

[177]There is no other evidence that Helladius wrote a *Life* of St Basil the Great, though he was his successor in the see of Cæsarea. The *Life of Basil* by his friend Amphilochius has a similar story, but there is no mention of an icon. The same story, presumably based on Amphilochius' *Life*, is found in John Malalas' *Chronicle*, book 13. 25 (ed. Dindorf, pp. 333–34; English trans. Jeffreys, 181–82), but again there is no mention of an icon: it is a dream.

[178]These passages are not from the *Dialogue on the Life of John Chrysostom*, composed after his death by his disciple, Palladius, but from a later *Life*, based on Palladius, by the seventh-century Bishop of Alexandria, George. The Proclus mentioned further on is John Chrysostom's disciple who later became Archbishop of Constantinople and had the saint's relics translated to Constantinople.

He had a depiction of the same apostle Paul in an icon, in the place where he used to rest for a little while because of his bodily infirmity; for he was given to many vigils beyond nature. And when he had finished his epistles, he would gaze at it and attend to him as if he were alive and bless him, and bring the whole of his thoughts to him, imagining that he was speaking with him in his contemplation.

And after other words:

As when Proclus ceased speaking, he gazed at the image of the apostle and beheld his character to be like the one who had appeared to him [i.e., John]. Making a reverence[179] to John, he said, pointing with his finger to the icon, "Forgive me, Father, the one I saw speaking to you is like this; indeed, I assume that it is the very same."

55 From the *Religious History* of Theodoret, bishop of Cyrrhus, on the life of Saint Symeon the Kionite:[180]

For about Italy it is superfluous to speak. For they say that in the great city of Rome the man became so celebrated that in all the porches of the workshops little icons of him had been set up to guard them and be a protection for those who used them.

56 St Basil, from his commentary on Isaias:[181]

Since [the devil] saw human kind in the image and likeness of God, not being able himself to betake himself to God, he poured out his wickedness on the image of God. Just as if someone is enraged [against the emperor], he throws stones at the image, since he cannot touch the emperor, he hits the wood that bears the likeness.

[179]Literally: *metanoia.*

[180]Theodoret, *History of the Monks of Syria*, 26.11 (PG 82.1473A 4–7; ed. Canivet–Leroy–Molinghen, II.182; Eng. trans. Price, 165): cited at Nicæa II. Saint Symeon the Kionite is the renowned Saint Symeon Stylites.

[181]Not in the extant commentary on Isaias by St Basil; this fragment (together with the comment in III.58) is also found in *Doctrina Patrum*, 329.4–10.

57 *Comment*: So everyone who honors the image clearly honors the archetype.

58 From the same commentary:[182]

For just as anyone who insults the royal image is judged as if he had done wrong against the emperor himself, so clearly anyone who insults what has been made in the image is liable to be tried for the sin.

59 St Athanasius, from the hundred chapters written to Antiochus the ruler in the form of question and answer, chapter 38:[183]

For we faithful people do not venerate images as gods, like the Greeks, not at all, but we declare the relationship only and the longing of our love for the character of the person of the image. Whence frequently, when the character has been smoothed away leaving bare wood, we burn up what was once an image.[184] Therefore, just as Jacob, when he was about to die, "made veneration, bowing down over the head of his staff,"[185] honoring not the staff, but the one who held the staff, just so, we faithful people do not embrace images in any other way, just as also our children kiss their parents, but that we may declare the longing of our souls. Just as the Jew venerated the tablets of the Law then and the two cherubim of cast gold, not honoring the nature of stone and gold, but the Lord who had ordered these things.

60 Chrysostom, on Psalm 3 on David and Abessalom:[186]

Emperors set up triumphal statues for victorious commanders, and rulers erect columns of victory for charioteers and athletes, and

[182]Basil, *Commentary on Isaias*, 13 (PG 30.589A = *Doctr. Patr.* 329.17–18).

[183]The "Questions and Answers" (*Erotapokriseis*), wrongly ascribed to St Athanasius the Great (PG 28.621BC = *Doctr. Patr.* 327.16–328. 3; the quotation in *Doct. Patr.* is longer than that cited by John, but textually much closer than that preserved in Migne).

[184]Cf. *Images*, II.19.

[185]Gen 47:31. Cf. *Images*, I.8; III.36.

[186]Chrysostom, *Commentary on Psalm 3* (PG 55.35). Abessalom is called Absalom, in English Bibles.

garlanding them with inscriptions make matter a herald of victory. Others again write panegyrics of victors in books and writings, wishing to show their power in the panegyric to be even greater than those praised. And writers and painters and sculptors in stone and the people and their rulers and cities and towns wonder at the victors. No one, however, made images for those who flee and do not fight.

61 Cyril of Alexandria, from his address to the Emperor Theodosius:[187]

Images are like archetypes; for it is necessary for them to be thus and not otherwise.

62 The same, from his *Thesaurus*:[188]

For images always bear the impress of their archetypes.

63 The same, from his work "That in all the Mosaic Scriptures the mystery of Christ is intended," on Abraham and Melchisedek, chapter 6:[189]

It seems fitting to me that images should be painted in accordance with their archetypes.

64 Saint Gregory Nazianzen, from his second homily on the Son:[190]

It is the very nature of the image to be a copy of the archetype and to be called after it.

[187]Cyril, *On the correct faith to Theodosios* (PG 76.1153D); also found in *Doctrina Patrum* (326.17–20).

[188]Idem, *Treasury on the Trinity* (PG 75.52A); also found in *Doctrina Patrum* (326.21).

[189]Idem, *Glaphyra on the Pentateuch, Gen.* II, *Abraham and Melchisedek* 8 (PG 69.104C).

[190]Gregory Nazianzen, *Hom.* 30.20 (ed. Gallay, 268); also found in *Doctrina Patrum* (326.23–25).

6 5 Chrysostom, from his third homily on Colossians:[191]

For if the image of the invisible were itself invisible, then it would not be an image; for an image, because it is an image, should be taken by us as precisely similar to what it represents, just as the type of a likeness.

6 6 The same, from his interpretation of the Epistle to the Hebrews, chapter 17:[192]

Just as among images the image of man has the figure, but not the power; so the truth and the figure share one with another, but the figure is equal . . .[193]

6 7 Eusebius of Pamphylus, from the fifth book of his *Demonstrations of the Gospel* on "God appeared to Abraham at the oak of Mamre":[194]

Thus even to this day the place is held to be divine and venerated by those who live nearby in honor of those who appeared to Abraham, and the terebinth remains to be seen and also, in a picture, those who were welcomed by Abraham, reclining, one on each side, and in the middle one better and greater in honor. The one who thus appears signifies to us the Lord himself, our Savior, whom those men reverence in ignorance of who he is, persuaded by his divine words. Hidden in human form and shape, he showed to our God-loving forefather, Abraham, who He was, and delivered to him knowledge of the Father, and from that he planted seeds of piety among human kind.

6 8 From the Chronicle of John Malalas, of Antioch, concerning the woman with the hæmorrhage, and the statue that she made for the Savior Christ:[195]

[191]John Chrysostom, *Hom.* 3 *on Colossians* (PG 62.318; ed. Field, V.200–1).
[192]Idem, *Hom.* 17 *on Hebrews* (PG 63.131; ed. Field, VII.208).
[193]John breaks off the quotation here; it continues: "but not its power."
[194]Eusebios of Caesarea, *Proof of the Gospel*, V.9 (ed. Heikel, 232).
[195]John Malalas, *Chronicle*, X (ed. Dindorf, 236–239; Eng. trans. Jeffreys, 125–7).
The translation is based on Jeffreys' translation, but I have followed John's text.

From then on John the Baptist became well-known to everyone and Herod, the toparch of the kingdom of Trachonitis, beheaded him in the city of Sebaste eight days before the Kalends of June in the consulship of Flaccus and Rufus. Therefore in his grief King Herod, the son of Philip, came from Judaea, and a certain wealthy woman, living in the city of Paneas, called Bernice,[196] approached him, wishing to set up a statue to Jesus, for she had been healed by him. As she did not dare to do this without imperial permission, she addressed a petition to King Herod, asking to set up a golden statue to the Savior Christ in that city. The petition ran as follows: "To the august toparch Herod, lawgiver to Jews and Hellenes, king of Trachonitis, a petition and request from Bernice, a dignitary of the city of Paneas. Justice and benevolence and all the other virtues crown your highness's sacred head. Thus, since I know this, I have come with every good hope that I shall obtain my requests. My words as they progress will reveal to you what foundation there is for this present preamble. From my childhood I have been smitten with the affliction of an internal hæmorrhage; I spent all my livelihood and wealth on doctors but found no cure. When I heard of the cures that Christ performs with his miracles, He who raises the dead, restores the blind to sight, drives demons out of mortals and heals with a word all those wasting away from disease, I too ran to him as to God. I noticed the crowd surrounding him and I was afraid to tell him of my incurable disease in case he should recoil from the pollution of my affliction and be angry with me and the violence of the disease should strike me even more. I reasoned to myself that, if I were able to touch the fringe of his garment, I would certainly be healed. I touched him, and the flow of blood was stopped and immediately I was healed. He, however, as though he knew in advance my heart's purpose, cried out, 'Who touched me? For power has gone out of me.' I went white with terror and lamented, thinking that the disease

[196]In the Latin tradition Veronica, which is close to how Bernice would have been pronounced (Verniki).

would return to me with greater force, and I fell before him covering the ground with tears. I told him of my boldness. Out of his goodness he took pity on me and confirmed my cure, saying, 'Be of good courage, my daughter, your faith has saved you. Go your way in peace.' So, your august highness, grant your suppliant this worthy petition." When King Herod heard the contents of this petition, he was amazed by the miracle and, fearing the mystery of the cure, said, "This cure, woman, which was worked on you, is worthy of a greater statue. Go then and set up whatever kind of statue you wish to him, honoring by the offering him who healed you." Immediately, Bernice, who had formerly suffered from a hæmorrhage, set up in the middle of her city of Paneas a bronze statue of beaten bronze, mixing it with gold and silver, to the Lord God. This statue remains in the city of Paneas to the present day, having been moved not many years ago from the place where it stood in the middle of the city to a holy place, a house of prayer. This document was found in the city of Paneas in the house of a man called Bassus, a Jew who had become a Christian. Included in it were the lives of all those who had ruled over the land of Judaea.

69 From the seventh book of the Ecclesiastical History of Eusebius of Pamphylus, concerning the woman with the hæmorrhage from Paneas:[197]

But since I have come to mention this city, I do not think it right to omit a story that is worthy to be recorded also from those that come after us. For they say that the woman who had a hæmorrhage, and who, as we learn from the sacred Gospels, found at the hands of our Savior relief from her affliction, came from this place, and that her house was pointed out in the city, and that marvelous memorials of the good deed, which the Savior wrought upon her, still

[197]Eusebius, *History of the Church* VII.18 (ed. Schwartz-Mommsen, 672; trans. Oulton, 174–6), following Oulton's translation, with modifications (partly determined by John's text).

remained. For [they said] that there stood on a lofty stone at the gates of her house a bronze figure of a woman, bending on her knee and stretching forth her hands like a suppliant, while opposite to this there was another of the same material, an upright figure of a man, clothed in comely fashion in a double cloak and stretching out his hand to the woman; at his feet on the monument itself a strange species of herb was growing, which climbed up to the fringe of the double cloak of bronze, and acted as an antidote to all kinds of diseases. This statue, they said, bore the likeness of the Lord Jesus. And it was in existence even to our day, so that we saw it with our own eyes when we stayed in the city. And there is nothing wonderful in the fact that those pagans, who long ago had good deeds done to them by our Savior, should have made these objects, since we saw the images of his apostles also, of Peter and Paul, and indeed of the Savior himself, preserved in pictures painted in colors. And this is what we should expect, for the ancients were wont, according to their pagan habit, to honor them as saviors, without reservation, in this fashion.

70 The same, from the ninth book of the same History, concerning the Emperor Constantine:[198]

For well he knew that his help was from God; and straightway he gave orders that a memorial of the Savior's Passion should be set up in the hand of his own statue; and indeed when they set him in the most public places of Rome holding the Savior's sign in his right hand, he bade them engrave this very inscription in these words in the Latin tongue: "By this saving sign, the true proof of bravery, I saved and delivered your city from the yoke of the tyrant; and moreover I freed and restored to their ancient fame and splendor both the senate and the people of the Romans."

[198]Ibid. IX.9.10–11 (ed. Schwartz-Mommsen, 832; trans. Oulton, 362–4), following Oulton's translation, with modifications (partly determined by John's text).

71 From Socrates' History of the Church, book one, chapter 18, concerning the same Emperor:[199]

And after these things the Emperor, being most attentive to Christian affairs, turned aside from pagan worship, and stopped the gladiatorial shows, and had his own images set up in the temples.

72 Stephen of Bostra, against the Jews, chapter 4:[200]

We make images of the saints in memory of the saints, such as Abraham and Isaac and Jacob and Moses and Elias and Zacharias and the rest of the prophets and the holy martyrs who were killed for his sake, so that everyone who sees their images may remember them and glorify the One who glorified them.

73 The same:

Concerning icons we are confident that every work done in the name of God is fair and good. Concerning idols and sacred statues, away with them, for they are evil and uncouth, both them and those who make them. For the icon of a prophet is one thing, but a sacred statue or figure of Kronos or Aphrodite, of the Sun or the Moon, is quite another. Since also human beings are in the image of God, they are to be venerated. The serpent, since it is an image of the devil, is unclean and to be despised. If you despise things made by hand, tell me, O Jew, what is there upon earth, not made by hand, that is to be venerated? Was the ark of God not made by hand? Or the altar or the mercy-seat or the cherubim or the golden jar containing the manna or the table or the inner tabernacle and everything that is called the Holy of Holies by God? Were not the cherubim made by hand, and the images of the angels? What do you say? If you disparage them by calling them idols, what do you say of Moses who venerated them, or Israel? For veneration is also a symbol of honor. Just as we sinners venerate God with divine worship and glorify him with worthy

[199]Socrates, *History of the Church* I.18 (ed. Hansen, 57–58).
[200]This and the next extract from Stephen of Bostra are only found in florilegia.

veneration and tremble before him as our creator and leader, so we venerate the angels and servants of God in accordance with divine honor as made by God and his servants; for an icon is the name and likeness of what is depicted on it.[201] Therefore also with letters and figures we make eternal memory of the Lord's sufferings and of the holy prophets, and of what is written in the Law and the Gospels.

74 Saint Gregory Nazianzen, from his discourse against Julian the Apostate:[202]

The icons, still publicly displayed, bear the marks of that plague.

75 Chrysostom, from his interpretation of the just Job:[203]

"In all of this that happened to him he did not give expression to folly before God."[204] Just as with images, whenever we describe someone in an historical work, we write "such a one dedicated this," so here, describing the image of his soul, he who is writing the book, he writes beneath it, as an inscription, saying, "In all of this that happened to him, Job did not sin."[205]

76 From the Life of Saint Constantine, book 4:[206]

The great strength of the divinely inspired faith fixed in his soul might be deduced by considering also the fact that he had his own portrait so depicted on gold coinage that he appeared to look upwards in the manner of one reaching out to God in prayer.

[201]Stephen of Bostra seems to be the first to make the distinction between veneration expressing divine worship (*latreia*), which is only offered to God, and veneration expressing honor (*timē*), which may be offered to anything that honors God or is honored by Him: a distinction taken up and developed by John Damascene.

[202]This passage cannot be found in either of Gregory's discourses against Julian (*Or.* 4 and 5).

[203]John Chrysostom, *Frag. on Job in the catena* (PG 64.544CD).

[204]Job 1:22.

[205]Ibid.

[206]Eusebius, *Vita Constantini*, IV.15–16 (ed. Heikel, 123; trans. Cameron-Hall, 158–59).

Impressions of this type were circulated throughout the entire Roman world. In the imperial quarters of various cities, in the images erected above the entrances, he was portrayed standing up, looking up to heaven, his hands extended in a posture of prayer. Such was the way he would have himself depicted praying in works of graphic art.

77 The same, book three:[207]

Thus passed away the Emperor's mother, one worthy of unfading memory both for her own God-loving deeds and for those of the extraordinary and astonishing offspring which arose from her. He deserves to be blessed, all else apart, for his piety to the one who bore him. So far had he made her God-fearing, though she had not been such before, that she seemed to him to have been a disciple of the common Savior from the first; and so far had he honored her with imperial rank that she was acclaimed in all nations and by the military ranks as *Augusta Imperatrix*, and her portrait was stamped on gold coinage.

78 The same, fourth book, chapter 69:[208]

The inhabitants of the imperial city and the Senate and People of Rome, when they heard of the Emperor's decease, regarding the news as dreadful and the greatest possible disaster, fell into unrestrained grief. Baths and markets were closed, as were public spectacles and all the customary leisure activities of happy people. The previously easygoing went about dejected, and together they all praised the Blessed One, the God-beloved, the one who truly deserved the Empire. Not only did they voice such cries, but took steps to honor him in death as if he were alive with dedications of his portrait. They depicted heaven in colored paintings, and portrayed him resting in an ætherial resort above the vaults of heaven.

[207]Ibid. III.47. 1–2 (ed. Heikel, 97; Cameron-Hall, 139).
[208]Ibid. IV.69 (ed. Heikel, 146; Cameron-Hall, 180–1).

79 The same, chapter 73:[209]

Just like him the Thrice-blessed instead of one became manifold by the succession of his sons, so that he is honored also by the setting up of portraits among all the provinces along with those of his sons.

8 0 Theodoret, bishop of Cyrrhus, and Polychronius, from their interpretation of Ezekiel:[210]

And just as the Romans, having painted imperial images, place bodyguards around them and make nations subject to them, in a like manner here: since the king in his vision gave form to God as raised on a throne over all on the earth, they depict images in this form and in an appropriate manner teach God's lordship over everything.

8 1 The same.

"And you, son of man, take a brick and place it before your face, and portray upon it the whole of Jerusalem; and give it an enclosure and build siege-works against it, and cast up a mound against it, and set camps against it, and place battering rams round about it."[211]

8 2 Interpretation:[212]

If it is deemed fearful to speak in opposition to the crowd and predict the sack of the city and the razing of the temple and the terrible things that accompany all this, show this to them in another way as both to chasten them and reveal your fairness. "And taking a brick," he says, "depict the city." Inscribe the name of the city, so that this is known to be "Jerusalem." Make a "mound" surrounding the city in the form of the depiction, indicating thereby that there is a mighty army. The powers approach in fighting array; for he says

[209]Ibid. IV.72 (!) (ed. Heikel, 147; Cameron-Hall, 182).

[210]Actually from fragments of a commentary on Ezekiel, now attributed to Apollinaris of Laodicea (Mai, VII.2, 82).

[211]Ezek 4:1–2.

[212]Polychronius, *Fragments on Ezekiel* (Mai, VII.2, 95).

"camps," instead of armed ranks, not only armed with weapons, but bringing up machines of war, with which they will demolish these walls; for the "battering rams" are meant for these walls. The city is only to be utterly amazed at its being surrounded by the multitude, so that, stricken with fear before such terrible things, it may put away its lawlessness.

83 From the Martyrdom of Saint Eustathius [or Eustace], also called Placida:[213]

One day, as he was going out following his custom into the mountains to hunt with his army and all his retinue, he saw a herd of deer grazing. Keeping his distance, according to his custom, he sent his army off in pursuit of them. While the whole band of soldiers was busy seizing the deer, the finest and most magnificent stag of the whole herd broke away from the herd and leaped from the copse into the densest and most impenetrable part of the wood. Seeing him and longing to seize him, Placida left the rest and went in pursuit with a few soldiers. He alone of his exhausted followers was persistent in the chase. By the providence of God, neither was his horse exhausted nor did he shrink from the difficulties of the place, and after a long pursuit he found himself far from his army. The stag attained a rocky mountain ridge [and stood there at the highest place. The general came up to him,][214] no one being with him, and he stood there, looking all around, wondering how he had caught the stag. But the all-wise and merciful God, who contrives all manner of means for the salvation of human kind, in the chase turned the hunter into the hunted, not like Cornelius through Peter, but like

[213]*Passion of Eustace/Placida*, in *Acta Sanctorum, September* VI (1757), 124. This, doubtless legendary, story of St. Eustace tells of one of Trajan's generals who was converted by the event recorded here. See also A. Grabar, *L'Iconoclasme byzantin. Le Dossier archéologique* (Champs, Paris: Flammarion, 1998; revised edition originally published 1984; first edition, 1957), fig. 158.

[214]The passage in square brackets is not found in the text of John's florilegium, but is supplied from the text of the *Passion*.

the persecutor[215] Paul through his own epiphany. After Placida had been standing there for some time, gazing at the stag, amazed at its size and at a loss how to seize it, the Lord showed him a kind of miracle, not altogether unnatural nor transcending his power in its magnitude, but, just as with Balaam he gave an ass speech in order to bring him to his senses,[216] so also here he showed by this upon the antlers of the stag the figure of the holy Cross, shining more brightly than the sun, and in the middle of the antlers the icon of the God-bearing body, which he accepted to assume for our salvation. And putting a human voice in the stag he addressed Placida saying, "O Placida, why are you chasing me?[217] Behold, for your sake I came close to you and was seen by you in this living being. I am Jesus Christ, whom, without knowing, you reverence.[218] For your good deeds, which you did to those who besought you, are present before me, and I came to manifest myself to you through this stag, and in return I have taken you alive and caught you in the nets of my loving kindness. For it is not right that one who is dear to me through his good deeds should be a slave to unclean demons and idols who are dead and dumb. For thus I came upon earth in this form, in which you see me, wishing to save the human race."

8 4 Saint Leontius of Neapolis on the island of Cyprus, To the Jews, discourse five:[219]

Come, and for the rest let us eagerly make a defense of the depiction of the august icons, so as to stop the mouths of those who speak unjust words.[220] For this tradition belongs to the Law, it is not ours.

[215]The Greek for "to pursue" (or "to chase") and "to persecute" are the same: *diōkein*.

[216]Cf. Num 22.

[217]Cf. Paul's account of his conversion (Acts 9:4, 22:7, 26:14), and see footnote 214 above.

[218]Cf. Acts 9:5 (and 22:8, 26:15), and also 17:23.

[219]The extracts from Leontius preserved in this third florilegium are different from those preserved in the florilegia to the first two treatises, and more like those cited at Nicæa II, though there are many minor differences.

[220]Cf. Ps 62:12.

Listen to God telling Moses to fashion two images of the cherubim, engraved and of cast metal, to overshadow the mercy-seat.[221] And again God showed Ezekiel the temple; it has, he said, engraved faces of lions and phœnixes, human beings and cherubim, from its foundation to the beamed work in the ceilings.[222] The account is truly awesome: the God who commanded Israel not to make any engraved image or likeness of anything, whether in heaven or on the earth,[223] the same orders Moses to make engraved living beings for the cherubim, and to Ezekiel God showed the temple full of engraved images and names of lions and phœnixes [or palms] and human beings. And Solomon, taking his model from the Law, made the temple full of engraved bronze—cattle and phœnixes [or palms] and human beings—and was not condemned by God for this.[224] If then you want to condemn me concerning icons, you are condemning God in advance who commanded these things to be made to remind us of him.

85 The same, from the fifth discourse:

Again the utterly godless laugh at us because of the precious Cross and the making and veneration of icons bearing divine likenesses, calling us idolaters and worshippers of wooden gods. If I were a worshipper of wooden gods, as you say, O godless one, then I would certainly also be a polytheist. If a polytheist, then I would be bound to swear, saying, "By the gods!," just as you, seeing one calf, said, "These are your gods, Israel!"[225] But it is unworthy ever to hear this from Christian mouths, though the adulterous and unbelieving synagogue is accustomed always to call the all-chaste Church of Christ a prostitute.

[221]Exod 25:18–20.

[222]Ezek 41:17–20. The above seems to me the most natural translation of the Greek, but in the passage from Ezekiel referred to *phoinix* does not mean "phœnix" but "palm tree."

[223]Cf. Exod 20:4.

[224]Cf. 3 Kgd 6:23–29.

[225]Exod 32:4.

86 The same:

For neither by us are the icons and types of holy figures vener-
ated as gods. For if we venerated as God the wood of the icon, then
we would certainly be ready to venerate any other wood, and not,
as often happens, burn in the fire the icon of a figure that has
worn away.[226] And again, so long as the pieces of wood are bound
together in the form of a cross, I venerate the form because of Christ
who was crucified on it; but if they are separated from each other,
then I throw them away and burn them. And just as one who receives
the sealed command of the emperor and kisses the seal does not
honor the wax, or the papyrus, or the lead, but assigns the reverence
and veneration to the emperor, so also the children of Christians,
when they venerate the form of the cross, do not venerate the nature
of the wood but, seeing the seal and ring and figure of Christ him-
self, through him embrace and venerate the one who was crucified
on it.

87 The same:

Therefore I depict and delineate Christ and the sufferings of
Christ in churches and houses and marketplaces and on icons and
shrouds and reliquaries and clothes and in every place,[227] that see-
ing these things continually I may remember them and not forget
them, as you always forgot the Lord your God. And just as when you
venerate the book of the Law, you do not venerate the nature of the
parchment or the ink, but the words of the Lord contained in them,
so when I venerate the icon of Christ, I do not venerate the nature
of the wood or the colors—God forbid!—but, venerating the lifeless
form of Christ, through it I seem to hold and venerate Christ
himself. And just as when his brothers sold Joseph, and Jacob
received from them the blood-stained coat of many colors, he kissed

[226]Cf. *Images*, II.19.

[227]Cf. the wording of the Definition of Nicæa II, which declares that the cross
and icons "may be set up in the holy churches of God, on holy utensils and vestments,
on walls and boards, in houses and in streets" (Mansi XIII.377D, in Sahas 1986, 179).

the garment with tears, and gazed upon it with his eyes, not mourning the garment, but through it thinking to kiss Joseph and hold him in his arms,[228] so also the children of the Christians, when they physically embrace the icon [of Christ] or an apostle or a martyr, reckon that they honor Christ himself or the martyr spiritually. Thus, as I have often said, the purpose must be examined in any act of greeting or veneration. If you accuse me, saying that I venerate the wood of the Cross as God, why do you not accuse Jacob, when he bowed in veneration over the head of Joseph's staff?[229] It is obvious that by bowing in veneration he was not honoring the wood, but through the wood venerating Joseph, just as we venerate Christ through the Cross. And when Abraham venerated those impious men who sold him the tomb and bent his knee to the ground, he did not venerate them as gods.[230] And again Jacob blessed the impious Pharaoh, who was an idolater, and also Esau seven times, but not as God.[231] Behold, how many greetings and venerations I have pointed out to you, both in Scripture and naturally, which did not merit condemnation. When you see me venerating an icon of Christ or his all-sacred Mother or a saint, you are immediately vexed and blaspheme and stalk off and call me an idolater, and without shame you shudder and blush, while every day you see me destroying the temples of the idols throughout the whole world and building temples of the martyrs. If I venerated idols, why should I honor the martyrs who cast down the idols? If, as you say, I glorify wood, how should I honor the saints who burnt up the wooden statues of the demons? If I glorify stones, how should I glorify the apostles who broke down idols of stone? If I reverence images of falsely-called gods, how should I glorify and praise and celebrate the feasts of the three children who contended in Babylon and would not venerate the golden image of an idol? But really all this is the hardening of the hearts of the

[228]Cf. Gen 37:32–34.
[229]Cf. Gen 47:31 LXX; also Heb 11:21.
[230]Cf. Gen 23:7–9.
[231]Cf. Gen 47:7–10; 33:3.

lawless, all blindness. O Jew, it is all your shamelessness and impiety; truly the truth is wronged by you. "Arise, O God, and defend your cause!"[232] Vindicate us and defend us from a nation not godly[233]— but ungodly and alien, continually provoking you.

88 The same:

If therefore, as I have frequently said, I venerate wood and stone not as gods, as if I were to say to wood and stone, "You gave me birth";[234] if I venerate the icons of the saints, or rather the saints themselves, and I venerate and honor the struggles of the martyrs, how do you say that these are idols, O fool? For idols are likenesses of falsely-called [gods], of adulterers and murderers, of child-sacrificers and catamites, and not of prophets or apostles. But in part to set before you a concise and most faithful illustration concerning likenesses among Christians and pagans, listen. The Chaldæans in Babylon had all sorts of musical instruments for the worship of demonic idols,[235] and the children of Israel from Jerusalem had instruments, which they hanged upon the willows;[236] in both cases there were instruments and ten-stringed lutes and lyres and flutes, but some were for the glory of God, others imitations for the worship of demons. So for the rest it is to be understood concerning icons and idols, pagan and Christian, that those were fashioned for the glory of the devil and in his memory, while these are for the glory of Christ and his apostles and martyrs and saints.

89 The same:

When therefore you see a Christian venerating the Cross, know that it is for the sake of Christ the crucified that he makes his veneration, not because of the nature of wood, as if we venerated all the

[232]Ps 73:22.
[233]Cf. Ps 42:1.
[234]Jer 2:27.
[235]Cf. Dan 3:4–7.
[236]Cf. Ps 136:2.

trees of the field, as Israel venerated sacred groves and trees, saying, "You are my God, you gave me birth."[237] Our case is not like that, but we have a memory and record of the sufferings of the Lord and of the deeds of those who contended for him, and we have them in churches and houses, making everything for his sake, for the sake of our Lord. And again, tell me, O Jew, what scripture permitted Moses to venerate Iothor, his father-in-law, who was an idolater,[238] and Jacob to venerate Pharoah,[239] and Abraham the sons of Emmor,[240] and Daniel Nabuchodonosor,[241] who was impious? If these, who were just men and prophets, did these things for the sake of this worldly and transient life, how do you accuse us who venerate the holy memories of the saints, whether depicted or written, and their sufferings and noble deeds, for the sake of which I am daily inspired to do good and shall receive eternal and everlasting life?

90 From Theodore's History of the Church, book 4:[242]

Under this consulship, in the month of December, on the thirtieth day, which was a Thursday, there occurred an awesome and extraordinary miracle, amazing to hear of. For a man by the name of Olympius, a follower of Euthymius, a teacher of the Arian way of worship, came into the baths at the Helenian palace to be rubbed down and seeing there among the bathers some who held in

[237]Jer 2:27.

[238]Cf. Exod 18:7 (Iothor is Jethro in English Bibles).

[239]Cf. Gen 47:7–10.

[240]Cf. Gen 23:7. Emmor is Hamor in English Bibles: see Gen 33:19, which refers to Jacob's purchase of land, an account that John, following Acts 7:16, conflates with Abraham's purchase of the cave as a sepulcher for Sarah.

[241]Cf. Dan 2:46. In fact, it is Nabuchodonosor (Nebuchadnezzar) who venerates Daniel, not *vice versa.*

[242]Theodore the Lector, *Historia Ecclesiastica*, frag. 52a (GCS, ed. G.C. Hansen, pp. 131–33). Theodore the Lector lived in Constantinople in the early sixth century, and compiled a "Tripartite History" from the Histories of Socrates, Sozomen and Theodoret, and a continuation written by himself. The latter work survives only in fragments.

reverence the glory of the *homoousian*[243] God, spoke to them in these words, "What is the Threefold?[244] Is it not something written on any wall?" And seizing his necessaries he said, "Look, I also have a threefold," so that those who found themselves there were moved to lay hands on him. But they were prevented by a certain Magnus, presbyter of the Holy Apostles by the Walls, a wonderful man and a servant of God, who told them that this would not escape the eye of all-bearing judgment that renders an exact record. Ceasing to give trouble out of respect for the man, Olympius got up and went to the entrance to the hot baths, where by custom it is allowed to take warm water. For there the water comes from a fountain that wells up in the middle of the sacred altar of the holy house of the protomartyr Stephen, which the enlightened Aurelian built long ago when he was ruler. From that time on I have held the water worthy of divine vision. Going down into this, he quickly came up again, crying, "Have mercy on me, have mercy!" and, scratching himself, he was tearing the flesh from the bone. Everyone gathered around him and, seizing him, wrapped a towel about him and leant over him lying at his last gasp. They asked him what had happened, and Olympius said, "Looking down, I saw a man dressed in white coming up to me from the cold bath, who poured three pails of hot water on me and said, 'Do not blaspheme!'" Putting him in a litter, they carried him over to another bath next to the church of the Arians. When they tried to unwrap the towel from him, the flesh came away too, and dying in this way he gave up the spirit. This soon became known in the whole court. Some spread a report about the one to whom this happened that, some years before, he had come from the worship of the *homoousion* to be rebaptized in the sect of Arius. When what had happened came to the ears of the emperors—it was in the time of

[243]Homoousios, "consubstantial": the key term in the creed of the Council of Nicæa (325), inserted to exclude Arianism; it became the mark of Orthodox Trinitarianism, which upheld the co-equality of the Persons of the Trinity.

[244]*Trias*: the Greek word for "Trinity," but unlike the English word it can mean any triad, not just the divinity.

Anastasius[245]—it was ordered that this miracle, depicted in color in an icon, should be set up above the cold bath. John, a certain deacon and legal representative of the aforementioned holy house of Stephen the first of the martyrs, and another man zealous for the doctrine of the *homoousion*, had the icon made, but not simply: for they inscribed the names of the bathers who had seen it, and the house of each, and the attendants at the baths. The icon bears witness up to the present, being set up at the entrance to the four-columned atrium of the oft-mentioned house of prayer. Since a miracle followed this miracle, it would not be proper to overlook something of such holiness, which since it has survived to the present day, I shall not hesitate to relate. For those of the Arian party, when they saw the prevailing victory, besought the official who was entrusted with the care of the Helenian palace and was charged with the administration of the baths to hide the icon. Finding a convenient excuse in the dampness produced by the water for taking away the troubling icon, he had it hidden for restoration, so he said. The emperor, making a tour of inspection of each part of the court, came there to find the icon, and so came to the wall. Immediately Eutychian (for this was the name of the house-steward) felt the force of the imperial wrath in the loss of his right eye. Fearing for the rest of his members, he made to approach the holy house of prayer, where a part of the sacred relics of the venerable Pantoleon and Marina were entrusted. The place is called "Harmony," since there the one hundred and fifty bishops assembled under the Emperor Theodosius the Great to make clear the common and agreed teaching about the *homoousion* of the divine Trinity and the Incarnation of the Lord by assumption from the Virgin, and it takes its name from this. He remained there for seven days to no purpose, his private parts causing him agony, when, in the middle of the night, a subdeacon, officiating at the all-night vigil, saw in a dream a certain emperor standing up and pointing with his hand to the sick man, saying,

[245]Emperor from 491 to 518.

"How can I bear him? Who brought him here? This is the one who conspired with those who blasphemed me. This is the one who has hidden the icon of the miracle." The cleric leaped up and related what he had seen, saying that it was attempting the impossible to heal this man of his scourge. The same night, Eutychian, led, as it were, from his pains into sleep, saw a certain young man, clad in a radiant, purple-edged garment, saying to him, "What do you want?" When he said, "I want to die, to dissolve away and be free from care," he heard him saying, "No one can help you, for the emperor is fearfully angry with you." He replied, "Where shall I move, or what shall I do?" And he said, "If you want to leave, go immediately to the Helenian bath and seek your rest close to the icon of the cursed Arian." Waking up directly, he called one of the attendants. He was amazed, for three days had already passed since he lost the power of speech. He called to them, commanding them to take him to the place prescribed. He reached the place, and set down before the icon he breathed his last. He who declares what he has seen proves that the soul knows freedom by finding distance from the body through being loosened from it.

91 Saint Anastasius, of the Holy Mountain of Sinai:[246]

About four miles from Damascus, there is a village called Karsatas, in which village there is a church dedicated to Saint Theodore. Saracens came into this church, and lived there, causing every kind of filth and uncleanness from women and children and animals. One day many of them were sitting together and one of them shot an arrow at the icon of Saint Theodore and hit it on his right shoulder, and immediately there came out blood, which flowed to the bottom of the icon, while they all looked at the sign that had taken place and the arrow sticking in the shoulder of the saint and the blood flowing. And even though such a sign had taken place, those who

[246]According to Kotter, this is an unedited story belonging to the *Spiritual Meadow* of John Moschus.

saw it were not moved to a sense of sin.[247] Neither did he who shot
the arrow repent, nor were any of them troubled in themselves, nor
did they leave the church, nor did they cease from defiling it. Never-
theless vengeance came upon them. In a few days' time, of the
twenty-four households of them that lived in the church, all of them
were destroyed by a bitter death, no one else in the village itself dying
save for those who were living in the church during those days. This
icon that was shot at is still there with the wound of the arrow and
the mark of the blood. Many are alive who have seen it and were
there when the miracle happened. And I, too, have seen his icon, and
having seen it, I have described what I have seen.

9 2 Arcadius, archbishop of Cyprus, from his account of the life of
Saint Symeon the Wonderworker, miracle 132:[248]

And it happened in those days that a certain man, a notary of the
city of Antioch, was caught in a terrible trap by a wicked demon and
confined for years, so that he was choked by it, with his respiratory
organs constrained. This man went to the saint and found healing
by his intercessions and became as if he had never suffered any evil.
Going back to his own house, in thanksgiving he set up an icon to
him in a public and conspicuous place in the city, above the doors of
his office. Certain of the unbelievers saw it thus honorably adorned
with lights and veils, and filled with zeal they stirred up unruly men
like themselves, so that a crowd gathered together and cried out
wildly, "Death to the one who did this! Let the icon be cast down!"
By the dispensation of God, it happened that the man could not be
found there in his house; for they were eager to seize him and there
was a general turmoil. Their wickedness was exceedingly great
before God, and their envy without measure, and inspired by that
they thought the time had come to rise up against the saint and

[247]Literally: consciousness.
[248]Arcadius of Cyprus, *Life of St Symeon* (ed. Van den Ven, I.139–41), telling of St
Symeon Stylites the Younger of the Wonderful Mountain (521–92).

insult him, for he had frequently reproached the false belief and error of those who practiced paganism among themselves. As they were therefore not able to carry out such madness, they ordered one of the soldiers to go up the steps and throw down the icon. When he went up and stretched out his hand to do what he had been told, he was hit from above and fell down to the ground, and there was a great uproar among the crowd. Incensed they made another go up, and just as he stretched out his hands to drag it down, he was like-wise struck down to the ground. When this happened, they all began to be afraid and started making the sign of the cross. Enraged still more the unbelievers made yet a third go up to it, and as he stretched out his hands to hurl the icon down, he again was struck to the ground. Then a great fear came upon all the faithful standing round and, astonished at the stubbornness and recklessness of those unbe-lieving, godless men, they withdrew to venerate the icon with prayer.

93 Saint John Chrysostom, from his homily on "Know that you are walking in the midst of snares":[249]

Let us not grieve, beloved, nor let us be cast down in the present affliction, but let us wonder at the ingenuity of God's wisdom; for through those things by which the devil expected to cast down our city God will raise it up and set it right. For the devil inspired certain godless men to insult the imperial statues, so that the very founda-tion of the city might be removed.

94 The same:[250]

Since these reckless events, when certain foul, indeed utterly repulsive, people trampled down the laws, and cast down the stat-ues, and threatened all, even to the last, with danger, and now, hav-ing provoked the emperor, we fear for our lives, no longer does the loss of possessions sting, but on every side I hear people saying, "Let

[249]John Chrysostom, *On the Statues* 15 (PG 49.154). The quotation is Sir 9:13.
[250]Ibid. 5 (PG 49.73).

the emperor take our substance, we shall gladly give up the markets and our homes, only let him undertake to leave us our naked bodies." So too here, before the fear of death came upon us, the loss of possessions distressed us, but since lawlessness has been endured, [the advent of fear] has expelled the pain of loss.

95 The same:[251]
Do you not know, that if anyone is not a robber, and is found in the cave of robbers, they will all receive the same judgment? But why do I speak of robbers? Stop, all of you, and recall that certain foul men and cheats cast down the statues, but those who were simply present when it happened were seized and taken to court and were given the ultimate penalty along with them.

96 Theodoret, bishop of Cyrrhus, from his History of the Monks of Syria, on Macedonius the Asianite:[252]
On another occasion, when the city was driven insane by some evil demon and vented its frenzy against the imperial statues . . .

97 From the History of the Church by Theodore the Reader of Constantinople, about a certain heretic, Palladius:[253]
Palladius, the bishop of Antioch, to gain the favor of the Emperor, loathed the followers of the holy dogmas of Chalcedon and cast down the icons of the holy fathers.

98 From the Life of Saint Constantine, the third book, chapter four:[254]
These things then were done as he desired. But the effects of the resentment of Envy dreadfully agitating the churches of God in

[251]Not to be found in *On the Statues*.
[252]Theodoret, *History of the Monks of Syria*, 13.7 (PG 82.1404; ed. Canivet–Leroy-Molinghen, I.486; trans. Price, 102).
[253]Theodore the Lector, *History of the Church*, frag. 51 (GCS, ed. Hansen, 131).
[254]Eusebius, *Vita Constantini*, III.4 (ed. Heikel, 78–9; Cameron-Hall, 122).

Alexandria, and the evil schism in the Thebaid and Egypt, disturbed him considerably. The bishop of one city was attacking the bishop of another, populations were rising up against one another, and were all but coming to blows with each other, so that desperate men, out of their minds, were committing sacrilegious acts, even daring to insult the images of the Emperor.

9 9 From the History of the Church, about those who thought like Dioscorus:[255]

Their recklessness reached such a pitch that the names of those who had been blessed shepherds there were removed from the diptychs, and their icons cast down and tyrannically burnt.

1 0 0 From the same History, about the successor to the heretic Macedonius on the throne of Constantinople:[256]

This godless man, when he arrived for services, ordered that the sacred icons were to be carefully examined and, if he ever found Macedonius depicted on an icon, he would not celebrate unless it were destroyed.

1 0 1 From the same History, about Julian and Timothy [Ælurus]:[257]

Certain of those who rejoiced at the troubles raised by the aforementioned Macedonius against Timothy the bishop applauded this Julian, and for this reason he found support. Misled by his

[255]Theodore the Lector, *History of the Church*, frag. 22a (GCS, ed. Hansen, 117). Dioscorus, a supporter of Eutyches, was patriarch of Alexandria in succession to Cyril (444–51), and was deposed at the Council of Chalcedon.

[256]Theodore Lector, *History of the Church*, frag. 58 (GCS, Hansen, 140). Macedonius, patriarch of Constantinople (496–511), supported the Emperor Zeno's *Henotikon*, which attempted to undermine Chalcedon. His successor was Timothy (patriarch, 511–18).

[257]Theodore the Lector, *History of the Church*, frag. 62 (GCS, ed. Hansen, 142). The Greek says "Timothy Ælurus" (patriarch of Alexandria, 457–60), but this is clearly a mistake, as the Timothy here is the patriarch of Constantinople already mentioned. Julian, early sixth-century bishop of Halicarnassus, maintained that the body of Christ was free from corruption even before the resurrection, a heresy called Aphthartodocetism.

supporters, both those present and those of influence in the bishop's circle, he contended that the decisions of the Council of Chalcedon should be overthrown and anathematized. The elder besought the icons painted of the deceased priests Flavian[258] and Anatolius,[259] archbishops of Constantinople, through whom the Council had acquired its authority, and cried out, "Do you want the decisions of this holy synod to be anathematized, and the icons of the bishops and the holy diptychs to be erased . . . ?"

102 Chrysostom, from his homily on Saint Flavian of Antioch:[260]

And the crowd manifested itself in its true colors. For, seized by an irrational impulse and egged on against the imperial icons and statues by the commander, they cast them down and dragged them through the marketplace. For madness robbed them of their senses, and rage blinded any sober thought.

103 From the patriarch Flavian's address to the Emperor Theodosius the Great, quoted in the same homily [of Chrysostom's]:

We have sinned, O Emperor; we do not hide our sin, the creation of which accuses us. We do not deny the madness, with which we raged against your icons, or rather against yourself, but, as condemned, we await your loving-kindness.

104 And again from the same address by Saint Flavian:

Do not cause such icons[261] to perish for the sake of one bronze icon. Do not smash such divine creations for the sake of one bronze creation that could easily be cast again.

[258]Flavian, patriarch of Constantinople 446–69, condemned at the "Robber Synod" of Ephesus in 449, which was overturned by the Synod of Chalcedon in 451.

[259]Anatolius, Flavian's successor as patriarch of Constantinople (449–58), and supporter of Chalcedon.

[260]Such a homily is unknown, though the passages cited in III.102–4 sound as if they refer to the episode of the Statues, from the homilies about which earlier extracts have been drawn. Flavian was bishop of Antioch 381–404, and went to plead with the Emperor for the people of Antioch after the affair of the statues.

[261]I.e., human beings, created in the image (icon) of God.

105 (cf. II.60) The same Chrysostom, that there is one lawgiver
of the Old and the New [Covenants], and on the clothing of the
priest:[262]

And I loved the picture in wax, full of piety; for I saw an angel in
an icon striking the companies of the barbarians and trampling
upon the tribes of the barbarians, and David speaking the truth:
"Lord, in your city you have brought their image to nothing."[263]

106 Saint Basil, his encomium of the Holy Forty Martyrs:[264]

Come then, let us make the profit that we gain from them com-
mon to all by setting up in our midst a memorial, and demonstrate
to all those present, as in a record, the valiant deeds of these men,
since both writers and painters describe the brave deeds of war, the
former adorning them with words, the latter inscribing them on
tablets, both inspiring many with their courage. For what the words
of a story make present through hearing, the same a picture indi-
cates silently through imitation.

107 St Gregory of Nazianzus, from his verses:[265]

Either do not teach, or teach by your way of life,
Lest with one hand you draw them, and the other push
 them away,
You will entreat less by speech, doing what is necessary.
The painter teaches better by his pictures.

108 Interpretation of the same:[266]

If you do not teach by your way of life, do not teach by word, lest
you drive away those you draw by your word by not having a good

[262]Actually from a homily by Severian of Gabala: PG 56.407; cited at Nicæa II.
[263]Ps 72:20.
[264]Of Sebaste: Basil, *Homily on the 40 Martyrs of Sebaste* (PG 31.508C-509A); also
cited in the *Doctrina Patrum* (329).
[265]Gregory Nazianzen, *Verses*, bk. I.33: PG 37.929A.
[266]John Damascene provides a prose translation of the preceding, somewhat
gnomic, verse.

way of life. For if you do what you have to do, this will be the perfect practice and principle of teaching, just as the painter teaches more through pictures.

109 The same:[267]

> Neither will I pass over Polemon.
> For it was a marvel much spoken of.
> Formerly he was not counted among the wise,
> But rather was a servant of exceedingly shameful pleasures;
> Later, he was possessed by longing for the good,
> Having found a counselor—I need not say who,
> Whether a certain wise man or even himself—
> Suddenly he was seen getting the better of the passions,
> So that I shall relate one of the marvels concerning him.
> A certain profligate youth invited in a whore,
> Who, when she was about to approach his door,
> Saw a picture of Polemon, prominently displayed,
> Which depicted him in all his venerability.
> Immediately she left, overcome by what she had seen,
> Put to shame by the one depicted, as if he were alive.

110 Chrysostom, on the Epistle to Timothy, chapter eight:[268]

"But set believers an example," "show yourselves in all respects a model of good deeds," that of the archetype of life; let him be like an image set before you.

111 From the address of the Holy Sixth Synod:[269]

Again Nestorius and again Celestine and Cyril, the one dividing Christ and condemning him, the others gathering up for the Master

[267]Gregory Nazianzen, *Verses*, bk. I.10; quoted at Nicæa II.

[268]John Chrysostom, *Hom.* 13 *on I Timothy* (PG 62.565; ed. Field, VI.103).

[269]That is, of the Sixth Ecumenical Synod, held at Constantinople in 680–81: act. 18, Mansi XI.661CD.

what had been divided and laying down a foundation. These things took place at Ephesus and of what was done there the tablets, with unwritten voice, speak silently.

112 The most ancient Clement, presbyter of Alexandria, from the seventh book of the *Stromateis*:[270]

Therefore, not only does he praise what is good, but he is compelled to be good, changing from the "good and faithful servant" through love into the "friend," through the perfection of habit, which he has acquired from true learning and much training. As therefore he attains the pinnacle of knowledge, compelled and adorned by his moral character, clothed in the form, having all those things that are excellences of the true gnostic, looking towards the good images, namely the many patriarchs who achieved success before him, the very many prophets and the humanly uncountable holy ones whom he reckons as angels, and above all the Lord who teaches that we can possess the life of the leaders and makes it possible.

113 Saint Theodore, bishop of Pentapolis:[271]

Again there was a certain leading man of that town, Dion by name, who had adorned the church of the holy martyr with many offerings and had made it an altar inlaid with silver. One of his household stole many of his possessions and went off with them. Dion did not pursue him but, going away to the icon of the saint, he rubbed the figure of the icon with wax, and with faith in the holy martyr put it on the porch of his house. The servant came to himself as if moved by someone and went to his own master, holding back nothing of what he had deprived him. Therefore, up to the present day everyone from that town who has learnt of this deals thus with those who make off with their possessions.

[270]Clement of Alexandria, *Strom.* VII.11 (ed. Stählin, 45).
[271]This passage is unknown apart from this citation.

114 St Athanasius of Alexandria, Against the Arians, book three:[272]

The Son, being the very offspring of the being of the Father, reasonably says that what is the Father's is his own; whence fittingly and consistently, after saying "I and the Father are one,"[273] he added, "that you might know, that I am in the Father and the Father in me."[274] And along with this again he declared that "one who has seen me has seen the Father."[275] And the meaning in these three sayings is one and the same. For one who thus knows that the Son and the Father are one knows that he is in the Father and the Father is in the Son; for the divinity of the Son is the Father's and it is in the Son. And one who grasps this understands that one who has seen the Son has seen the Father; for the divinity of the Father is seen in the Son. One might understand this more closely from the example of the image of the Emperor; for the form and shape is in the image of the Emperor, and the form in the image is in the Emperor. The likeness in the image of the Emperor is exact, so that one who sees the image sees the Emperor in it and again one who sees the Emperor understands that this is in the image. From the fact that the likeness is not changed, the image might say to one who, after the image, wished to see the Emperor: "I and the Emperor are one; for I am in him and he is in me, and what you have seen in me, this you see in him, and what you have seen in him, this you see in me; for the one who venerates the image venerates in it the Emperor. For his shape and form is the image."

115 The same, to Duke Antiochus;[276]

What do they say to these things, those who turn away from and give up venerating the figures of the saints, who have been depicted amongst us for a memorial?

[272]Athanasius, *Against the Arians* III.5 (PG 26.329C-332B); cited at Nicæa II.
[273]Jn 10:30.
[274]Jn 10:38 (cf. 14:11).
[275]Jn 14:9.
[276]Ps-Athanasius, *Questions to the Duke Antiochus* (PG 28.621CD).

116 Ambrose, bishop of Milan, to Gratian the Emperor on the incarnate dispensation of the God the Word:[277]

God before the flesh and God in the flesh. But beware, they say, lest in assigning to Christ two governing [parts of the soul] or a double wisdom we should seem to divide Christ. But, when we venerate his divinity and his flesh, do we divide Christ, or, when we venerate in him both the image of God and the cross, do we divide him? Not at all!

117 Cyril, patriarch of Jerusalem, from the twelfth Catechesis:[278]

If then you seek the reason for the coming of Christ, have recourse to the first book of the Scriptures. In six days God made the universe, but the universe was for the sake of human kind; for the sun, in all its radiantly shining brightness, was made, we say, for the sake of human kind. And all the living beings were established to serve us, and plants and trees created for our enjoyment. Everything that was fashioned is good, but none of these is the image of God, save only human kind. The sun was created by a command only, but human kind fashioned by the divine hands; "let us make human kind after our image and our likeness."[279] The wooden image of an earthly king is honored, how much more the rational image of God?

118 Saint Basil, to Saint Flavian on the Samaritan woman:[280]

In the passage where our Lord gives a new teaching about veneration that has been led astray by local custom, he says, "it is necessary to worship in Spirit and in truth,"[281] clearly saying that he is the Truth. Just as we say that we venerate the Father in the Son, as in the image of God the Father, so also in the Spirit, as pointing in himself to the divinity of the Lord.

[277]Ambrose, *On the Sacrament of the Lord's Incarnation*, 7.71 and 75 (CSEL 79, ed. Faller, 7: lines 90 and 122–7, pp. 260 and 262).

[278]Cyril of Jerusalem, *Catechesis*, 12.5 (ed. Rupp, 8).

[279]Gen 1:26.

[280]Unknown apart from this citation.

[281]Jn 4:24.

119 Saint Gregory of Nazianzus, on baptism:[282]

If after baptism the persecutor of light assails you—and he will assail you, for he also assailed the Word my God, assailing the hidden light through his appearance—you have the means to conquer him; do not fear the struggle. Defend yourself with the Spirit; defend yourself with the Water.

And, a little later:

Putting your confidence in the seal, say: "I am the image of God; I have not yet been cast down from glory through exalting myself, as you have been. I have put on Christ, I have been changed into Christ through baptism. You should venerate me!"

120 Saint John Chrysostom, on the Maccabees:[283]

One may find depictions of the imperial figures not only radiant in gold and silver and precious materials, but also the same shape is already to be seen worked in bronze. And the difference of the material does not harm the worth of the figure, nor does participation in the lesser dim the honor of the better, but the imperial figure equally magnifies any material and, in no way diminished by the material, it causes it to receive even greater honor.

121 The same, from the first discourse against Julian the Atheist:[284]

What is this new Nabuchodonosor? For this one manifests no more loving-kindness towards us than the old one; for his coals still trouble us, even if we have escaped the flame. Do the memorials[285] of the saints that are laid up in the churches for the veneration of the faithful suggest that the body is dishonorable?

[282]Gregory Nazianzen, *Hom.* 40.10. 1–5, 30–34 (ed. Moreschini, 216–18).

[283]John Chrysostom, *Panegyric on the Maccabees,* frag. (PG 49/50.629).

[284]Unknown apart from this citation. "Atheist" is an alternative appellation for Julian the Apostate.

[285]*Anathēmata*: more usually offerings. The context in the florilegium suggests that it means icons, though the actual argument of the passage would more naturally suggest that it means relics; neither of these meaning are attested in Lampe, however.

122 The same, on the basin:[286]

For just as, when the imperial statues and images are sent down and carried into the city, the rulers and the people meet them with praise and fear, they are not honoring the planks, or the wax-covered tablets, but the statue of the Emperor, and likewise creation itself . . .[287]

123 Severian of Gabala, on the Cross, fourth discourse:[288]

"Moses struck the rock once and twice."[289] Why once and twice? If he is obedient to the power of God, what need is there of a second blow? If he strikes independently of the power of God, neither a second nor a tenth nor even a hundredth blow will be able to render the unfruitful nature fruitful. If therefore the work is of God simply, apart from the mystery of the Cross, once suffices, a nod suffices, a word suffices. But that it might prefigure the image of the Cross, it takes place in this way. "Moses," it says, "struck once and twice," not in the same direction, but making the form of the cross, that the lifeless nature might be ashamed of the symbol of the cross. For if the image of an absent Emperor fulfils the place of the Emperor, and rulers venerate it, and sacred festivals are celebrated before it, and rulers meet it, and the people venerate it, not looking at the wooden plank, but at the figure of the Emperor, who is not seen to be present by nature, but is depicted by art, how much more is the image of the immortal Emperor able, not only to strike stone, but the heaven and the whole earth?

[286]Severian of Gabala, *On the Washing of the Feet on Holy Thursday* (ed. Wenger, 226); cited at Nicæa II.

[287]John breaks off the quotation; it continues: "honors not the earthly vessel, but reverences the heavenly image."

[288]Severian of Gabala (?), *On the Cross* (in the works of Chrysostom, ed. Savile, V.898).

[289]Num 20:11.

124 From the Chronicle of Isidore the Deacon:[290]

Theophilus sinned, when he slandered John Chrysostom to the Empress Eudoxia, saying that he followed the heresy of Origen; the Augusta became enraged against John on the pretext of the widow's vineyard, and because of this sin Theophilus was not able to die until the icon of Chrysostom was brought to him; and he venerated it and breathed out his spirit.

125 Jerome, presbyter of Jerusalem:[291]

None of your Scriptures enjoin you to venerate the Cross, for what reason then do you venerate it? Tell us Jews and Greeks and all the nations who ask you.

Answer: Therefore, O senseless and shameless of heart, God has perhaps allowed every nation that reverenced God to venerate some human work upon earth, in order that they might no longer be able to accuse Christians about the Cross and veneration of icons. Therefore, just as the Jew venerated the ark of the covenant and the two cherubim of cast gold and the two tablets, which Moses had wrought in stone, even though nowhere had he been enjoined by God to worship or embrace these things, so also Christians do not embrace the Cross as God, but as showing the genuine disposition of our souls towards the Crucified.

126 The great Symeon of the Wonderful Mountain, on icons:[292]

Equally one of the unbelievers, eager to engage in dispute, may say that because we venerate icons in churches we are to be reckoned as praying to lifeless idols. God forbid that we should do such a thing! For these are matters that belong to the faith of Christians, and our God who cannot lie works miracles. For it is not as if we

[290]Not found elsewhere.

[291]Not found elsewhere.

[292]Symeon Stylites Junior, *On Icons*, frag. For this fragment, and more fragments from this same sermon and another on the first two commandments, see Thümmel, *Frühgeschichte*, 322–23.

venerate the surface appearance, but, calling to mind the one depicted in the painting, we look to the invisible by means of the visible picture, and understand him to be present, not trusting in a God who is not, but One who truly is, nor in the saints as non-existent, but as existing and living with God, and their holy spirits as existing and by the power of God helping those who are worthy to entreat them.

127 (cf. II.66) Anastasius, archbishop of Antioch, to Symeon, bishop of Bostra, on the Sabbath:[293]

For just as when the Emperor is absent his image is venerated, so when he is present it would be pointless to desert the archetype and venerate it through an image; but when [the image] is not venerated because of the presence of that for the sake of which it is venerated, it should in no way be dishonored. And I think that something similar is the case with the shadow of the Law, or the letter, for the Apostle calls it a shadow.[294] For inasmuch as grace is kept in reserve until the time of truth, the saints, beholding the truth as in a mirror, speak beforehand in terms of figures. But when the truth has come they do not think it good to live in accordance with the figures and to follow them still. For when the things themselves are present, then the figures of the things withdraw. But they did not at all thus dishonor them or put them away, but honoring the figure they judged those who sought to dishonor them irreverent and worthy of death through bitter punishment.

128 The same, the third discourse:[295]

Just as if anyone venerates the image of the Emperor, it is owing to the honor of the emperor and not because of the wax and the colors.

[293]Anastasius of Antioch, *Fragment on the Sabbath* (PG 89.1405A, B).
[294]Cf. Heb 10:1.
[295]Anastasius of Antioch, *Fragment on the Sabbath* (PG 89.1405C).

129 The Fifth Holy and Ecumenical Synod, anathema 12:[296]

If anyone defends the irreverent Theodore of Mopsuestia, who said that God the Word is one, while quite another is Christ, who was troubled by the passions of the soul and the desires of human flesh, was gradually separated from that which is inferior, and became better by his progress in good works, and could not be faulted in his way of life, and as a mere man was baptized in the name of the Father and the Son and the Holy Spirit, and through this baptism received the grace of the Holy Spirit and came to deserve sonship and to be venerated, in the way that one venerates the statue of the emperor, as if he were God the Word . . .: let him be anathema!

130 Theodore the historian of Constantinople, from his History of the Church, about Gennadius, archbishop of Constantinople:[297]

I shall set down other things about him full of amazement. A certain painter, while painting an icon of Christ our Master, found that his hand shriveled up. And it was said that, as the work of the icon had been ordered by a certain pagan, in the adornment of the name of the Savior he had depicted his hair divided on his forehead, so that his eyes were not covered—for in such a way the children of the pagans depict Zeus—so that those who saw it would think that they were assigning veneration to the Savior.

131 (cf. II.65) Abba Maximus and Bishop Theodosius and the officials sent from the Emperor:[298]

The venerable[299] Maximus said, "since it seems that this has happened, there is a way out from what has been thought; and in

[296]Constantinople II, anathema 12, ed. Tanner, I.119.

[297]Theodore the Lector, *History of the Church*, frag. 11 (ed. Hansen, 107–8). Gennadius I was patriarch of Constantinople from 458 to 471; the account in the *Epitome* reveals that Gennadius healed the painter's hand.

[298]From the *Disputation between St Maximos the Confessor and Theodosios the Bishop at Bizya* (PG 90.156; ed. Allen-Neil, *Disp. Bizya* lines 460–67 on p. 116–17); cited at Nicæa II.

[299]"Venerable" = *hosios*, the appellation of a monastic saint.

whatever you command, I shall follow you." And at this everyone
rose with joy and tears and made a reverence,[300] and prayer took
place, and each of them kissed the holy Gospels and the precious
Cross and the icon our God and Savior Jesus Christ and of our Lady,
the all-holy Mother of God, who bore him, placing their own hands
as a confirmation of what had been spoken.

132 Saint Sophronius, from the Miracles of the holy martyrs Cyrus
and John, on Theodore the subdeacon, who had gout:[301]

We shall speak further on the strengthening of the body, giving
an account in a few words. After a few days, he slept and again saw
the martyrs standing before and commanding him to accompany
them. He most eagerly followed them, for he knew that to go with
the saints was not without reward. We came then to a perfect church,
awesome and dazzling in form, in its height touching the heavens,
and on entering we saw a very great and wonderful icon, having in
the middle the Master Christ painted in colors, on the left our Lady
the Mother of God, on the right John the Baptist, who acknowledged
[Christ] beforehand by skipping while he was in the womb, since
being within his speech could not he heard,[302] and certain of the glo-
rious chorus of the apostles and prophets and the assembly of the
martyrs. Among them were the martyrs Cyrus and John, who stood
before the icon, and fell down on the knees before the Master, touch-
ing the ground with their heads, interceding for the healing of the
young man. These were the words of their petition: "Master, Lover
of human kind, do you command that we may give healing to him?"
Many times they bowed down to the ground, and uttered the words
of their petition, and as the Master Christ did not nod his assent,
they ceased from their petitioning and, downcast and dejected, they
came towards me, standing not far from the icon. And when they

[300]*Metanoia.*
[301]Sophronius of Jerusalem, *Miracles of Cyrus and John* (PG 87.3557C-3560C);
cited at Nicæa II.
[302]Cf. Lk 1:41.

were close, they said, "Do you see how the Master does not want to give you healing? But do not be discouraged, for he is certainly kind to you, as he is towards all." After standing back for about half an hour, they departed and again besought him. But again unsuccessful, they came back, downcast and dejected, since, as before, the Master Christ had not given the command. And coming up they spoke to me again. A third time they set off, saying, "Be of good courage, for now we shall certainly obtain grace; but you also come with us and petition the Master, as you see us make petition." And, coming to the icon a third time, they used the same gestures and words as before. And after they had prayed for a full hour, prostrating themselves and crying out only, "Master, will you give the command?," Christ, in his pity, was compassionate [and nodded his assent],[303] and he uttered "Grant it him" from the icon. And getting up from the ground the martyrs first gave thanks to Christ our God, who had heard their prayer.

133 Saint Anastasius of the Holy Mountain of Sinai, on New Sunday and on the Apostle Thomas:[304]

Those who saw Christ in the flesh held him to be a prophet, but we who have not seen him, nor touched him with the soft tips of our fingers, children and young people, confess him to be God, of supreme authority, Almighty, and creator of the ages and the effulgence[305] of the Father—for seeing that same Christ speaking, so we hear with faith his glad tidings—and as we receive the immaculate pearl of his body, we understand it to bear Christ, and if we see, as it were, only his divine character depicted, as if he were gazing down on us from heaven, we fall down in veneration. Great now is the faith of Christ.

[303]Words in square brackets omitted by John.
[304]Otherwise unknown. "New Sunday" is the Sunday after Easter, or Thomas Sunday: see Lampe, *s.v. kyriakos*, 4.d.v (786).
[305]Cf. Heb 1:3.

134 From the Life of Abba Daniel, on Eulogius the stonemason:[306]

Then, downcast, he departed and threw himself down before the icon of the Mother of God and said with groaning, "Lord, release me from the pledge this man holds."

135 From the Life of Mary the Egyptian:[307]

As I was crying, I saw the icon of the all-holy Mother of God standing above the place where I stood. And I said to her, "Virgin, Mother of God, Lady, who gave birth to God the Word in the flesh, I know, indeed I know, that it is neither fitting or reasonable for someone so defiled, so utterly prodigal, to look at the icon of you, the Ever-Virgin, but it is right for me to be hated and loathed by your purity. But since it came about that God was born from you as a man for this reason that he might call sinners to repentance, help me, a lone woman who has no one to help her. Command that I, too, may be allowed entrance. Do not prevent me from seeing the Cross, on which God the Word, whom you bore, was crucified in the flesh, who gave his own blood as a ransom for me. Command, O Lady, that to me, also, the door may be opened for the divine veneration of the Cross. And I name you before God who was born from you as a worthy guarantor, that I shall no longer insult this flesh by any kind of shameful intercourse. But, as soon as I behold the wood of the Cross of your Son, I shall immediately renounce the world and all that is in the world, and straightaway go out, wherever you, as my guarantor, shall enjoin me and lead me." As I said all this, I received the fire of faith as a kind of assurance and, emboldened by the compassion of the Mother of God, I moved myself from the place where I had been standing to make my prayer, and went again and mingled among those who were entering. No longer was I pushed this way and that, and no one prevented me from approaching the door,

[306]*Life of Daniel* (ed. Clugnet, 258).

[307](Ps?-)Sophronius, *Life of Mary of Egypt* 23–25 (PG 87.3713B–3716A; cf. trans. by Maria Kouli in Alice-Mary Talbot [ed.], *Holy Women of Byzantium* [Washington DC: Dumbarton Oaks, 1996], 82–84); cited at Nicæa II.

through which they were entering the church. Shivering and amazement seized me, and I was shaking and trembling all over. I threw myself to the ground and, when I had venerated that holy ground, I eagerly ran out to her who had become my guarantor. I then came to the place where the bond of guarantee was signed and, kneeling before the Ever-Virgin Mother of God, I prayed, using these words: "O Lady who loves the good, you have shown me your love for human kind, do not abhor the prayer of an unworthy woman. I have seen the glory that the prodigal rightly cannot see. Glory to God who accepts through you the repentance of sinners." And so on.

136 From the Life of Saint Eupraxia:[308]

And the deacon[309] said to the maiden, "Depart, my lady, to your house, because you cannot remain here. For no one can remain here, unless she is joined to Christ." The maiden said to her, "Where is Christ?" The deacon showed her the figure of the Lord. And having turned,[310] she said to the deacon, "Truly I join myself to Christ and I can no longer go away with my lady."[311] And again Eupraxia got up and placed her daughter[312] before the figure of the Lord and stretched out her hands to heaven and cried with groaning, "Lord Jesus Christ, care for this your child, because she longs for you and commends herself to you."

137 The Holy Synod that met under Justinian concerning the Holy Fifth Synod:[313]

[308] *Life of Eupraxia* (text in *Acta Sanctorum*, March II (1668), col.729 C and D).

[309] A female deacon (or deaconess, but the Greek is *diakonos*, not *diakonissa*) called Theodoulē, who was attached to the sisterhood.

[310] "Having been converted"?

[311] Her mother.

[312] Not her natural daughter: Eupraxia was a benefactor of the sisterhood, and treated this young girl as her daughter.

[313] The Synod *in Trullo* met under Justinian II to provide disciplinary canons to complement the doctrinal decisions of the Fifth (and the Sixth) Ecumenical Synods (hence it is often called the Quinisext, or Fifth-sixth, Synod). The passage cited is canon 82 (ed. Joannou, 218–20). It was cited also at Nicæa II.

In certain paintings of the sacred icons, a lamb is depicted, to which the Forerunner points with his finger, a lamb which is taken as a figure of grace, prefiguring to us through the Law the true Lamb, Christ our God. While we embrace the ancient figures and shadows handed down in the Church, as symbols and foreshadowings of the truth, we prefer grace and truth,[314] which we receive as the fulfilment of the Law.[315] Since it is what is perfect that is to be depicted for the eyes of all in colored work, we decree that henceforth in icons the Lamb who takes away the sin of the world,[316] Christ our God, is to be presented in his human form instead of as the ancient lamb, so that, coming to understand through his humility the greatness of God the Word, we may be led to a memory of his life in the flesh and his passion and the redemption of the world that consequently came about.[317]

138 Saint Methodius, bishop of Patara, On the Resurrection, second discourse:[318]

For example, then, the images of our emperors here, even if they are not fashioned of more precious materials, such as gold and silver, are honored by all. For, while they respect those made from more precious materials, people do not hold others in less respect, but honor all equally, even if they are made of chalk or bronze. And one who slanders either kind is not acquitted as if he had only spoken against clay, or judged for having disparaged gold, but for having shown disrespect to the emperor and lord himself. So when we fashion from gold images of [God's] angels, of the principalities and authorities, we make them for his honor and glory.

[314]Cf. Jn 1:14.
[315]Cf. Rom 13:10, and Jn 1:16.
[316]Jn 1:29.
[317]These last few lines are slightly different from the critical text of the canon, and in particular omit mention of "his saving death."
[318]Methodius, On the Resurrection, II.24 (ed. Bonwetsch, 379). This treatise only survives in an Old Slavonic translation, apart from fragments, many of which are preserved in John Damascene's Hiera (or Sacra Parallela).

Bibliography

Abbreviations

CCSG Corpus Christianorum Series Graeca
CSEL Corpus Scriptorum Ecclesiasticorum Latinorum
CSS Cistercian Studies Series
GCS Griechische Christliche Schriftsteller
PTS Patristische Texte und Studien
SC Sources Chrétiennes

Primary Sources

Acta Sanctorum (Antwerp, 1643–1770; Brussels, 1780–86, 1845–83, 1894ff.; Tongerloo, 1794; Paris, 1875–87).

Allen, Pauline, and Bronwen Neil, (edd.), *Scripta Saeculi VII Vitam Maximi Confessoris Illustrantia*, CCSG 39 (Turnhout: Brepols/Leuven: University Press, 1999).

Ambrose, *de Incarnationis Dominicae Sacramento*, in CSEL 79, ed. by O. Faller (Vienna, 1964).

Arkadius of Cyprus, *La vie ancienne de S. Syméon Stylite le Jeune (521–92)*, ed. by P. Van den Ven, 2 vols., Subsidia Hagiographica 32 (Brussels, 1962–70).

Aubineau, M., "Jean Damascène et l'epistula de inventione Gervasii et Protasii attribuée à Ambroise," *Analecta Bollandiana*, 90 (1972), 1–14.

Basil the Great, *Sur le Saint-Esprit*, ed. by Benoît Pruche OP, SC 17*bis* (Paris: Cerf, 1968).

Clement of Alexandria, *Stromata* VII and VIII, etc., ed. by O. Stählin, revised by L. Früchtel, GCS 172 (Berlin: Akademie-Verlag, 1970).

Cyril of Jerusalem, *Catecheses illuminandorum* 1–18, in *Cyrilli Opera*, vol 1, ed. by G.C. Reischl, vol. 2, ed. J. Rupp (Munich, 1848–60).

Dionysius the Areopagite, *De Divinis Nominibus*, ed. by Beata Suchla; *De Coelesti Hierarchia, De Ecclesiastica Hierarchia*, ed. by Günther Heil; *De Mystica Theologia, Epistulae*, ed. by A.M. Ritter, in *Corpus Dionysiacum*, 2 vols., PTS 33, 36 (Berlin-New York: Walter de Gruyter, 1990–91).

Doctrina Patrum de Incarnatione Verbi. Ein griechisches Florilegium aus der Wende des 7. und 8. Jahrhunderts, ed. by Franz Diekamp, second edn. Basileios Phanourgakis-Evangelos Christos (Münster: Aschendorff, 1981; originally published 1907).

Eusebius of Caesarea, *Demonstratio Evangelica*, ed. by I.A. Heikel, GCS 23 (Leipzig: J.C. Hinrichs, 1913).

————, *Historia Ecclesiastica*, ed. by E. Schwartz and Th. Mommsen, GCS 9, 2 parts (Leipzig: J.C. Hinrichs, 1903–8); *The Ecclesiastical History*, Schwartz-Mommsen text, with translation by Kirsopp Lake and J.E.L. Oulton, 2 vols., Loeb Classical Library (London: Heinemann/ Cambridge MA: Harvard University Press, 1926–32).

————, *Vita Constantini*, ed. by I.A. Heikel, GCS 7 (Leipzig: J.C. Hinrichs, 1902); *Eusebius. The Life of Constantine*, translated with commentary and introduction by Averil Cameron and Stuart Hall (Oxford: Clarendon Press, 1999).

Gregory of Nazianzus, *Discours 27–31 (Discours théologiques)*, ed. by Paul Gallay, together with M. Jourjan, SC 250 (Paris: Cerf, 1978).

————, *Discours 38–41*, ed. by Claudio Moreschini, SC 358 (Paris: Cerf, 1990).

Gregory of Nyssa, *De deitate filii et spiritus sancti et in Abraham*, in *Gregorii Nysseni Sermones*, part 3, ed. by E. Rhein et al. (= *Gregorii Nysseni Opera*, ed. by W. Jaeger et al., vol. X, part 2 [Leiden-New York-Cologne: Brill, 1996]).

Joannou, Périclès-Pierre (ed.), *Discipline Générale Antique*, tome I, I, Les canons des conciles œcuméniques (Grottaferrata: Tipografia Italo-Orientale «S. Nilo», 1962).

John Chrysostom, *Interpretatio omnium epistolarum Paulinarum*, ed. by F. Field, 7 vols., (Oxford: J.H. Parker, 1849–62).

John of Damascus, Bonifatius Kotter OSB (ed.), *Die Schriften des Johannes von Damaskos*, 5 vols., PTS 7, 12, 17 (= *On the Divine Images*), 22, 29 (Berlin-New York: Walter de Gruyter, 1969–88).

John Malalas, *Historia Chronica*, ed. by L. Dindorf, Corpus Scriptorum Historiae Byzantinae (Bonn, 1831); English trans. by Elizabeth Jeffreys et al.,

Byzantina Australiensia 4 (Melbourne 1986).

John Moschus, *The Spiritual Meadow*, trans. by John Wortley, CSS 139 (Kalamazoo: Cistercian Publications, 1992).

Life of Daniel: "Vie et récits de l'abbé Daniel, de Scété, éd. par M.L. Clugnet," *Revue Orientale Chrétienne*, 5 (1900), 49–73, 254–71, 370–406.

Mai, Angelo, ed. *Nova Patrum Bibliotheca*, 8 vols. (Rome, 1844–71).

Mansi, J.D. (ed.), *Sacrorum Conciliorum Nova et Amplissima Collectio*, 31 vols. (Florence, 1759–98).

Methodius of Olympus, ed. by G. Nathanael Bonwetsch, GCS 27 (Leipzig: J.C. Hinrichs, 1917).

Severian of Gabala, *Homilia in lotione pedum*, in A. Wenger, "Une homélie inédite de Sévérien de Gabala sur le lavement des pieds," *Revue des Études Byzantines*, 25 (1967), 225–29.

———, *In pretiosam et vivificam crucem*, in *Opera S. Joannis Chrysostomi*, ed. by H. Savile, vol. 5 (1612).

Socrates, *Kirchengeschichte*, ed. by G.C. Hansen, together with M. Sirinjan, GCS NF 1 (Berlin: Akademie-Verlag, 1995).

Tanner SJ, Norman P. (ed.), *Decrees of the Ecumenical Councils*, 2 vols. (London: Sheed and Ward/Washington DC: Georgetown University Press, 1990).

Theodoret of Cyrrhus, *Histoire des moines de Syrie*, ed. by P. Canivet and A. Leroy-Molinghen, SC 234, 257 (Paris: Cerf, 1977–9); *A History of the Monks of Syria*, trans. R.M. Price, CSS 88 (Kalamazoo: Cistercian Publications, 1985).

Secondary Sources

Alexakis, Alexander, *Codex Parisinus Græcus 1115 and Its Archetype*, Dumbarton Oaks Studies, 35 (Washington DC: Dumbarton Oaks Research Library and Collection, 1996).

Allies, Mary H. (trans.), *St John Damascene on Holy Images, followed by Three Sermons on the Assumption* (London: Thomas Baker 1898).

Anastos, Milton, "Leo III's Edict against the Images of the Year 726–7 and Italo-Byzantine Relations between 726 and 730," *Byzantinische Forschungen* 3 (1968), 5–41.

Anderson, David (trans.), St John of Damascus, *On the Divine Images*

(Crestwood NY: St Vladimir's Seminary Press, 1980).

Auzépy, Marie-France, *La Vie d'Étienne de Jeune par Étienne de Diacre*, Introduction, edition and translation, Birmingham Byzantine and Ottoman Monographs, 3 (Aldershot: Ashgate Variorum 1996).

Bryer, A. and J. Herrin (edd.), *Iconoclasm* (Birmingham, 1977).

Cameron, Averil, "The Language of Images: the Rise of Icons and Christian Representation," in *The Church and the Arts*, Studies in Church History, 28, ed. by Diana Woods (Oxford: Blackwell Publishers, 1992), 1–42.

Chase, Frederic H. (trans.), Saint John of Damascus, *Writings*, with introduction, Fathers of the Church, 37 (New York: Fathers of the Church, 1958)

Cormack, Robin, *Writing in Gold. Byzantine Society and Its Icons* (London: George Philip 1985).

Grabar, André, *L'Iconoclasme byzantin. Le Dossier archéologique* (Champs, Paris: Flammarion, 1998; revised edition originally published 1984; first edition 1957).

Hennephof, Herman, *Textus Byzantini ad iconomachiam pertinentes*, Leiden: E.J. Brill 1969). [Cited by item, not page, number.]

Henry, Patrick, "What was the Iconoclast Controversy about?" *Church History*, 45 (1976), 16–31.

Hussey, J.M., *The Orthodox Church in the Byzantine Empire* (Oxford: Clarendon Press, 1986).

Kitzinger, E., "The Cult of Images in the period before Iconoclasm," *Dumbarton Oaks Papers*, 8 (1954), 85–150

Louth, Andrew, *Saint John Damascene: Tradition and Originality in Byzantine Theology*, Oxford Early Christian Studies (Oxford: University Press, 2002).

Mathew, Gervase, *Byzantine Aesthetics* (London: John Murray, 1963).

McGuckin, John A., "The Theology of Images and the Legitimation of Power in Eighth-Century Byzantium," *St Vladimir's Theological Quarterly*, 37 (1993), 39–58.

Munitiz, J.A. et al., with J. Chrysostomides, E. Harvalia-Crook, Ch. Dendrinos, *The Letter of the Three Patriarchs to Emperor Theophilos and Related Texts* (Camberley: Porphyrogenitus, 1997).

Murray, Mary Charles, "Art and the Early Church," *Journal of Theological Studies*, NS, 28 (1977), 304–45

Noble, Thomas F.X., "John Damascene and the History of the Iconoclast

Controversy," in *Religion, Culture and Society in the Early Middle Ages: Studies in Honor of Richard E. Sullivan* (Kalamazoo: Western Michigan University Press, 1987), 95–116.

Payton, James R., jnr., "John of Damascus on Human Cognition: An Element In His Apologetic For Icons," *Church History*, 65 (1996), 173–83.

Pelikan, Jaroslav, *The Spirit of Eastern Christendom (600–1700)*, The Christian Tradition: A History of the Development of Doctrine, 2 (Chicago and London: Chicago University Press, 1974).

——— (1990). *Imago Dei. The Byzantine Apologia for Icons* (New Haven-London: Yale University Press, 1990).

Sahas, Daniel J., *Icon and Logos. Sources in Eighth-Century Iconoclasm* (Toronto-Buffalo-London: University of Toronto Press, 1986).

Talbot, Alice-Mary (ed.), *Holy Women of Byzantium*, Byzantine Saints' Lives in Translation, 1 (Washington DC: Dumbarton Oaks Research Library and Collection, 1996).

Thümmel, H.G., *Die Frühgeschichte der ostkirchlichen Bilderlehre. Texte und Untersuchungen zur Zeit vor dem Bilderstreit*, Texte und Untersuchungen zur Geschichte der altchristlichen Literatur, 139 (Berlin-Akademie Verlag, 1992).

POPULAR PATRISTICS SERIES

ST VLADIMIR'S SEMINARY PRESS
1-800-204-2665 • www.svspress.com